DOCUMENTING DESIGN

WORKS ON PAPER IN THE EUROPEAN COLLECTION OF THE ROYAL ONTARIO MUSEUM

Howard Creel Collinson

ROM
Royal Ontario Museum

University of Toronto Press
Toronto Buffalo London

© 1993 Royal Ontario Museum

ISBN 0-8020-0557-8 (cloth)
ISBN 0-8020-7454-5 (paper)

First published in 1993 by the Royal Ontario Museum, 100 Queen's Park, Toronto, Ontario M5S 2C6

and

University of Toronto Press Incorporated, 10 St. Mary Street, Suite 700, Toronto, Ontario M4Y 2W8

Canadian Cataloguing in Publication Data
 Collinson, Howard Creel, 1956–
 Documenting design: works on paper in the European Collection of the Royal Ontario Museum

 Exhibition schedule: Royal Ontario Museum, Toronto,
 Mar. 27–Aug. 29, 1993.
 ISBN 0-8020-0557-8 (bound) ISBN 0-8020-7454-5 (pbk.)

 1. Design – Europe – History — Exhibitions.
 2. Drawing, European – Ontario – Toronto – Exhibitions.
 3. Prints, European – Ontario – Toronto – Exhibitions.
 4. Royal Ontario Museum. European Dept. – Exhibitions.
 I. Royal Ontario Museum. European Dept. II. Title.

 NC225.C64 1993 741.94'074'713541 C93-093488-1

Jacket/Cover illustrations: (front) Gottfried Bernhard Göz, *Design for a Facade Painting with Allegorical Figures of Earth and Air,* 1740–1743 (No. 45); (back) Victor Moscoso, *Junior Wells,* 1968 (No. 31) and Heinrich Aldegrever, *Two Spoons and a Hunting Whistle,* 1539 (No. 1).

Title page illustration: Detail from Jean-Charles Delafosse, *Design for a Clock,* c. 1770 (No. 43).

This publication is issued in conjunction with the exhibition *Documenting Design: Works on Paper from the European Collection of the Royal Ontario Museum,* held at the Royal Ontario Museum, Toronto, 27 March 1993 to 29 August 1993.

Printed and bound in Canada

For Mona Campbell
with affection and gratitude

CONTENTS

Preface
vii

Acknowledgements
viii

Introduction
1

Catalogue and Alphabetical
List of Artists Represented
11

Works Cited
117

PREFACE

The collection of works on paper in the European Department of the Royal Ontario Museum (ROM) was founded in the 1920s, at a time when the ROM collected virtually anything and everything, and when it was not yet clearly established that the European collections would focus almost exclusively on decorative arts, sculpture, and arms and armour. Although the initial plans were to create an encyclopedic collection of works on paper reflecting the history of printing, the collection was assembled haphazardly for a few years, with almost nothing added after 1939.

Until 1955, the European Department was called the Modern European Department in the Royal Ontario Museum of Archaeology. This is key to understanding any of the Department's collections. In this scheme, modernity began in the year A.D. 1000. The archaeological roots of the collection are still detectable today. The Department's collections were not acquired as aesthetic objects, but were always viewed as cultural artifacts like potsherds and points. Nearly fifty thousand objects (not counting some 165,000 postage stamps) range from exquisite 18th-century furniture to archaeological ceramics. Because of this breadth of scope, the collections have often suffered—or profited—from a lack of focus.

In the last decade, the ROM's European Department has attempted to concentrate its energies on a more cohesive area of endeavour, with partial success. However, as art history has focused increasingly on the cultural context of art, the ROM's traditional archaeological perspective has been adopted to some extent by the mainstream of the discipline. This was the situation in 1985, when the European Department decided to awaken its dormant collection of prints and drawings as an adjunct to the primary holdings of European decorative arts.

This exhibition draws from the approximately six hundred works acquired between 1986 and 1992. Despite the generosity of several donors, the collection began with relatively limited resources and can never hope to be encyclopedic, even within its defined scope. Rather, its purpose is to illustrate selected aspects of the role played by works on paper in the history of decorative arts, as well as to document the history of several genres of works on paper.

ACKNOWLEDGEMENTS

I am grateful to many colleagues who have assisted in the research on our collections which has led to this catalogue, especially the staffs of the print rooms at the Victoria and Albert Museum; the Musée des Arts Décoratifs, Paris; the Kunstbibliothek, Berlin (Dr. Christine Thon); the Staatliche Graphische Sammlung, Munich; the Städtische Kunstsammlungen Augsburg (Dr. Rolf Biedermann); the Staats- und Stadtbibliothek Augsburg (Dr. Helmut Gier); and Graphische Sammlung of the Staatsgalerie Stuttgart (Dr. Ulrike Gauss). Krysztof Ciuk and Dr. Hugh Wylie of the Royal Ontario Museum were generously helpful. The library of the Zentralinstitut für Kunstgeschichte in Munich was an invaluable resource, as were the library of the Royal Ontario Museum and its staff.

Thanks are due to the many donors and supporters of the European Department who have helped with the acquisition of these works. Mona Campbell deserves special thanks for her support, not just as a patron of the Museum, but as friend of the European Department in many ways. Both the acquisition and the exhibition of this collection are the work of the entire Department. June Rilett has organized our office and our lives. Technicians Sandra Bernaus and especially Torrie Lowther-Munroe have cared for the collection and indulged the curator with unending patience. The ROM's Paper Conservator, Janet Cowan, has never complained about being asked to resuscitate a piece of paper and works at the highest professional standard. Margo Welch and Lory Drusian have seen the exhibition through to completion with their usual efficiency.

This book would not have appeared in any form without the support of Sandra Shaul, Head of Publications and Print Services at the ROM, and would not have taken the form it now has without the skills of Glen Ellis, Managing Editor; Kat Mototsune, Editor; Virginia Morin, Designer; and Vickie Vasquez-O'Hara, Production Co-ordinator. I am especially pleased that this is a part of the ROM's program of co-publication with the University of Toronto Press and express my thanks to Joan Bulger, Editor, for her enthusiasm and support and to Nancy Harding, Assistant Production Manager, for her invaluable assistance.

My curatorial colleagues, K. Corey Keeble, Brian Musselwhite, and Dr. C. Peter Kaellgren, have supported this endeavour, both before and after my arrival at the ROM. During my many absences they have assumed added burdens. They have never stinted with the Department's resources and have shared their enthusiasm and vast knowledge of decorative arts with generosity.

INTRODUCTION

Thmis exhibition, and the collection of works on paper in the European Department of the ROM, are meant to demonstrate the complex and varied role of prints and drawings within the history of decorative arts and design. Historically, works on paper have been the medium used for creating and transmitting styles of ornament; for developing and presenting designs for objects in designers' drawings; for expressing design in products of graphic design; and for recording the use of decorative arts in original contexts such as spectacle, court festivities, interior design, and table settings. Collections of these works perform two functions simultaneously. They can be used to complement a decorative arts collection, expanding the amount and kind of information about the history of objects that a museum is able to present. Such a collection may also present the separate histories of the works on paper themselves. For a field such as the history of printed ornament, this can provide insight into the stylistic and economic history of a large category of works on paper that is too frequently overlooked or underemphasized in the history of prints and drawings.

Collections of prints and drawings related to decorative arts and design form part of various types of institutions, although the emphasis is different in each. The collection of the Kunstbibliothek in Berlin, a division of an art reference library rather than of a decorative arts museum, includes most of the relevant categories of works initially collected as teaching material. Appropriately, this collection of prints and drawings related to design is now housed in a complex that includes both the decorative arts museum and the separate collection of the Kupferstichkabinett, where works on paper are collected as art, not as information. A different aspect of these works is reflected by the Metropolitan Museum of Art, New York, which collects all these genres, not as an adjunct to its decorative arts collection, but as elements of its encyclopedic collections of prints and drawings.

Among decorative arts museums, the two that are the most direct models for the ROM's prints and drawings collection are the Victoria and Albert Museum, London, and the Cooper-Hewitt Museum, the Smithsonian Institution's National Museum of Design, New York. Both have collections that reflect all the complex possibilities for the role of works on paper as informative documentation of decorative arts history and as independent works of art. This dual nature of the works as documents/works of art is not only a product of the reception and collection of these works but, for at least the printed images, is an essential quality of the genre.

To understand the objects either as documents or as works of art, they must be examined in the context of their original function. Of course, this can be said of any work of art. These pieces, however, often have a much more specific and limiting function than most autonomous works of art. The significant factors affecting their form may range from technical requirements to market forces to stylistic tradition. Some of these factors are traced in the catalogue entries on individual works.

Printmaking must be fundamentally differentiated from drawing. Printmaking was used to create "working images" because of its power to create reproducible images, rather than for aesthetic reasons. The dissemination of the image is the primary function of these prints. This is fundamental not only to their intended function but also to their value as documents. Through printed images, we can study the transfer of ideas as well as the development of style in ornament. Printmaking has been linked to decorative arts from its inception. One of its initial uses was in the manufacture of models for craftsmen and artists. Indeed, the medium of engraving originated in the goldsmith's craft, where printed impressions first may have been used to make workshop records of engraved designs (a form of reproducing the engraved original).

No. 4, detail

Model prints, whether representing objects or abstract patterns, are known in the study of the history of printmaking as "ornament prints." In this exhibition, works such as the Italian grotesque design (No. 2) or the sheet from Christoph Jamnitzer's *Neuw Grottessken Buch* (No. 4) were meant to provide a vocabulary of motifs for artisans in many fields. Most of the printed objects in the collection were intended to serve this purpose. Yet, shortly after the beginning of ornament prints in the late 15th century, this genre grew into an independent field of artistic expression. Printmakers created works of broader content. While they could be used as models, they are also self-contained works of art. Whether Aldegrever's jewel-like 1539 engraving of *Two Spoons and a Hunting Whistle* (No. 1) is primarily a model for goldsmith's work or a still life of three objects with symbolic meaning is not easily decided.

Throughout the history of ornament prints, there are many works whose nature is similarly ambiguous. One reason for this may be economic. A simple pattern sheet had limited usefulness and a limited market. Designers and publishers of patterns sought to appeal not only to the broadest possible range of working craftsmen but to an audience of connoisseurs and potential patrons who collected the sheets for their own information and as works of art. This led to an elaboration of the genre, which reached its climax in the period between 1660 and 1760. The printing, by means of counterproofing, of some of Jean Le Pautre's *Alcoves à la françoise* (No. 11) as complete, symmetrical images, leads to the conclusion that they were functional images to be used as models. But other sets of Le Pautre's designs for alcoves are enhanced by narrative scenes set in the depicted space. This makes the images more attractive but would only serve to confuse anyone trying to copy the architectural ornament. His set of *Designs for Urns* (No. 11) presents portraits of grandiose objects as much as it provides models to be copied in stone or bronze. Le Pautre also published etchings of landscapes and narratives. For him, and for many other artists, the creation of ornament

images was often quite removed from any direct application to the design of real objects; rather, the designs were an end in themselves. Ornament was simply one genre of printed image, alongside other types such as landscape, portraiture, and animals.

The history of the "grotesque" provides an instructive example. Initially derived from ancient Roman art (see No. 2), this genre of ornament recurs continually from the late 15th century through at least the mid 18th century. The incorporation of elements of the grotesque into various styles of Western ornament was one of the driving forces in the stylistic evolution of the genre. For several centuries, printed grotesque ornament functioned virtually as a design laboratory. It appears primarily in images that are not meant for specific objects, but its influence is easily seen in model sheets as well (No. 12). There is a constant dialogue between designers who create "pure" ornament and those who apply it to specific tasks. While prints after the grotesque designs of Jean Berain (No. 13) were useful as model sheets for decorative arts and were used as such across northern Europe, they are also magnificent self-sufficient images that evolved from and referred to a long tradition of printed ornament. The Berain design in this exhibition is ultimately based on the mid-16th-century Italian engraving (No. 2). His stylistic developments were conditioned both by the decorative arts of his period and by the evolution of printed ornament.

The great masterpieces of ornament from French designers of the 18th century, such as Jean Mondon's *Livre de formes ornées de rocailles* (No. 15), are a sign of the independence of the ornament print. As in the Rococo style in general, ornament was an end in itself, not something to be applied to other objects. Rococo objects have been described as not being decorated, but rather as consisting of pure ornament. Analogous to this are prints of the period that do not show identifiable objects such as coffee pots or tables, but instead depict ornamental forms as if they were objects. Artisans may have been able to take motifs and ideas from these designs, but they could take motifs and ideas from any image. These prints were hardly more immediately applicable to the design of objects than are landscapes or narrative scenes.

This phenomenon can be easily observed in the products of the large printmaking industry in Augsburg during the late 17th and the 18th centuries when ornament prints were a specialty of the city's publishers. While Augsburg artists did produce many straightforward pattern sheets, the best talents were engaged in creating images that shared the vocabulary of decorative arts and ornament but did not illustrate actual objects. Indeed, the relationship of the printed model to actual objects could become the subject of the image as in the visual elisions in some works by Johann Esaias Nilson (No. 19 b, c). The two "designs for objects" by Nilson in the exhibition are not meant as models for craftsmen, but simply refer to the syntax of such images. Such works are both the climax and the death knell of the tradition of multivalent ornament images. Within the collection, these minor masterworks of the Rococo are of interest more as representations of general stylistic trends of their period than for specific use as models.

Autonomous ornament sheets are the pinnacle of artistic achievement in this area, but for the purpose of documenting design, unambiguous model sheets have obvious value at the other end of the spectrum. These certainly continued to be made in the 18th century. The designs for furniture in Neufforge's massive book on architecture are meant as models, not as beaûtiful images (No. 20). The 18th century was a great period for model books, seen here in works such as Chippendale's *Director* (No. 17) and Piranesi's *Diversi Maniere* (No. 21). Pattern books for craftsmen became even more explicit in the 19th century, evinced by the Prussian government's *Vorbilder für Fabrikanten und Handwerker* (No. 23) or the encyclopedic compendia of ornament such as Owen Jones' *The Grammar of Ornament* of 1856.

These two genres within the concept of ornament prints, which evolved from one source, always produced hybrid offspring. The production of images that were both patterns and self-sufficient pieces continued in works such as the volumes of chromolithographs that recorded the objects displayed at international exhibitions and in the spate of new periodicals of the late 19th and early 20th centuries that were now aimed at working designers, theorists, dealers, and consumers, all of whom constituted, and continue to constitute, their intended market. Volumes of original prints of ornament subjects, the mainstay of ornament for four hundred years, disappeared. A book such as Süe and Mare's *Architectures* (No. 27) is an elegant relic of an outmoded genre. Art Déco style was characterized by luxuriously handcrafted objects, which defied the logic of the industrial age. That preciosity and exclusivity are reflected in the limited-edition, hand-printed volume. Within the exhibition, this grand book provides a worthy conclusion to this extinct species.

The reproductive nature of printing is inherent also in those works that are themselves the end products of a design process. For our purposes, these can be defined as works on paper that are to be used as objects. This aspect of decorative arts also began in the 15th century, with Italian engravings meant to decorate box lids. This realm of design, like early printed ephemera, is largely lost to us because of the poor survival of individual works and is represented in the exhibition by several late works.

No. 27, detail

Even the products of graphic design are not collected as an end in themselves. The 19th-century menu cards in Japanese style (No. 24), Albert Robida's cover for *La Caricature* (No. 25), and George Auriol's lithographed front for a theatre program (No. 26) are evidence of the taste for *Japonisme* that swept the Western world in the later 19th century. These works are collected

here simultaneously as works of art or design and as documents of the cultural environment of the entire production of decorative arts of their era.

The history of graphic design is still more obviously shown in the European Department's growing collection of posters. In the exhibition, the thesis sheet by François Spierre after a design by Pietro da Cortona (No. 7) indicates the existence of large-scale graphic design before Jules Cheret's creation of the modern poster in the 1860s. But as with the examples of *Japonisme,* all the posters in the exhibition are related to contemporary devel-

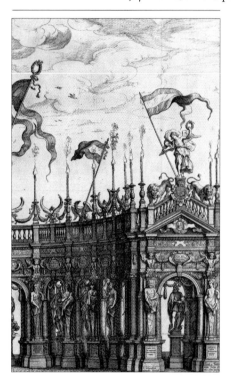

No. 10, detail

opments in design as a whole. Stelletski's poster for the benefit for Russian artists in Paris (No. 28), like Indiana's New York City Opera poster (No. 30), are indicative of themes and visual styles prominent in the design of objects in their time. The 1988 Neo-Op Psychedelic handbills produced on a photocopying machine (No. 35) are an odd mix of nostalgia for a recent past and exploitation of new technologies that make each person his or her own graphic designer.

The dissemination of design ideas is not the only role of works on paper, and the history of that process is not the only phenomenon they can illustrate. Works on paper allow a museum collection to encompass "uncollectible" aspects of decorative arts. For the purposes of such documentation, it is less crucial whether the work is printed or drawn. While a museum collection is naturally oriented toward media that can be collected (ceramics, glass, textiles, etc.), it presents a warped reflection of the history of Western decorative arts. To illuminate the cultural context from which decorative arts emanate rather than just to trace the history of the objects in this collection, we must focus attention on all the aspects of decorative arts that were significant vehicles for expression in their age. A good example is the volume of etchings after Rubens' designs for the ceremonial entry in 1635 of Ferdinand of Austria into Antwerp (No. 10). This event was a major expression of Northern Baroque art, including the contemporary taste in decoration. The effort and money invested in this ceremony by the city fathers of Antwerp was immense, much more than the cost of a painting or the most lavish piece of Baroque gold. Clearly, such ceremonies, like court festivities, are impossible to collect and display in their original form. Works on paper not only record these events but, like the Rubens book, can be significant works of art in themselves.

Another important aspect of decorative arts, which is only collectible with great difficulty, is the historic interior space, especially in a manner that gives any clue as to the relative importance of the objects it contained. While this is imperfectly represented in the exhibition, two major drawings give some opportunity to consider these issues. Sir James Thornhill's drawing for the unexecuted ceiling painting for the Great Hall at Easton Neston

(No. 36) records a major English Baroque decorator's work for a noted patron. Artistically significant furnishings and objects played an important role in the representational purpose of an English country estate. In a museum collection those objects are no longer seen in the context of a great interior with the iconography or the style of the other contents, such as the panelling or the architectural paintings. In the case of the Thornhill, if our speculation as to the subject matter is correct (Queen Anne as Britannia Promoting the Arts), the painting would have helped to turn the entire interior into a statement of Lord Lempster's conception of his place in the social hierarchy of Britain, and of Britain's role in the world at large.

No. 36, detail

In a similar manner, Ange-Jacques Gabriel's elevation for a wall in the apartment of the Dauphine at Versailles (No. 40) is rewarding for the study of the hierarchy of decorative arts in 18th-century France. It is important evidence of court style and patronage. The conservatism of the style of court decoration is clear, as is the indication of the grandeur of patronage. The demolition of this elaborate interior, when its intended inhabitant died shortly after taking occupancy, is remarkable documentation of the way an entire carved interior could be treated as a piece of "furniture" which, having served its purpose, could be discarded. Conversely, the drawing shows the manner in which one element of the furniture, the side table, was regarded as part of the wall scheme. The side table, the monarch of the realm of furniture, was an integral part of the architectural treatment of the interior. Designed along with the room and created by the woodcarver who executed the walls, it held special meaning and importance, which is not evident when it is seen dislocated to a later placement, for example, to a decorative arts gallery.

Images can document the history of the crafts and trades involved in decorative arts, from illustrations in instructional manuals to images of craftsmen at work. The two views of workshops in the exhibition show the vastly different social positions of the 17th-century gunmaker in his independent artisanal workshop (No. 8) and the workers in a porcelain factory in the 18th century (No. 22). The latter, who worked in an industry that in the 1770s was still controlled by royal manufactories, are shown in a palatial setting, with the more elevated members of the shop dressed as gentlemen. The comical picture of a goldsmith from Nicolas de Larmessin's set of trades (No. 14) is not just a 17th-century pictorial joke, but shows common products of such a smith.

The functions served by drawings in the creation of decorative arts can also be found in drawings related to other fine arts. Initial sketches, detail studies, presentation drawings, and working drawings could all exist for either a clock or a painting. What is perhaps different in a collection oriented

toward decorative arts is a stronger interest in the documentary value of drawings than in sheer aesthetic power. If the purpose of the ROM's collection is to explore the context of the production of decorative arts, then drawings play a central role because they frequently are the only documentation of that context.

Context for decorative objects is literally evoked in the two views of interiors in the exhibition, discussed above. Context in a more abstract, economic sense is demonstrated by the many contract drawings surviving for the decorative arts. Contract drawings, broadly defined, were drawings shown to a patron for approval before manufacture began. They are the most common type of surviving drawing related to design, since they were preserved by patrons or craftsmen as legal documents and records. They cannot always be differentiated from drawings that served as workshop models.

The drawings for the Augsburg silver centrepiece (No. 47) and the Tegernsee silver book cover (No. 48) depict objects that have not survived, providing evidence of entire genres of objects that are largely destroyed. If we did not have so many drawings for these types of silver centrepieces from Augsburg, we would be hard-pressed to believe that these magnificent objects were as common as archives indicate. Nor would we have a very complete concept of what such objects may have looked like as a class.

No. 47, detail

Contract drawings also give an indication of the relative importance of types of objects and materials. The fact that designs for metalwork are so frequently drawn at full scale, dramatically indicated by the design for an ecclesiastical candlestick (No. 38), is a clear indication of the importance of the objects—primarily due to the value of their material. The drawings are often accompanied by an indication of the weight of the silver to be used.

Drawings also provide visual confirmation of aspects of the historic "design process." In the late 20th century, we have a tendency to overlook the collaborative nature of earlier decorative arts. Designers and makers are not identical now, nor were they in past centuries. It is routine to refer to Fabergé products, for example, as if Peter Carl Fabergé had actually made them; rather, they were designed and made under his supervision. The drawings from the Fabergé workshops (Nos. 52–53) are clearly models created by professional designers working in the firm. The drawings for the Augsburg centrepieces may be designs for objects or drawings of objects that already existed, or both. They seem to record options available to the patron of the silver dealer.

The drawing by Jean-Démosthène Dugourc for a hardstone bowl (No. 44) is inscribed to one of the royal manufacturers. In addition to documenting

the kind of information necessary for the execution of the bowl, the drawing shows that its maker, Aubert, did not design his own products, but was a craftsman carrying out his orders. The drawing for a *secrétaire* (No. 41) seems to relate to a specific piece of furniture made by Adam Weisweiler, but the drawing is highly unlikely to be by him, and calls into question his exact role in designing his own products.

As with any drawings, these works are perhaps most interesting for what they can reveal about a designer's thought process. The two drawings for a *kovsh* from the Fabergé workshops (No. 53), show the designer creating several options in the first drawing and then choosing from them in his traced finished copy. The Hoffmann drawing for a set of ceramic wares (No. 54) clearly indicates his concern with the harmonious relationship of the various pieces. Naturally, earlier designers of similar sets had also shared this concern, but evidence of how such sets were worked up is rare. The simple outline style of the Hoffmann drawing also shows the clarity of profile that characterizes the completed ceramics.

No. 54, detail

Finally, Christof Rädle's *Cultur Bag* (No. 34) prompts consideration of an important problem for the collection. It is easy to defend the suggestion that his design makes a wry comment on the nature of design and culture in a global economic system, but is it easy to defend the presence of a plastic bag in a collection of works on paper? As the nature of decorative arts changes over the course of centuries, so the focus of the collection must change. If the European Department's collections were intended primarily to document the history of glass, ceramics, or furniture, for instance, it would be an easy decision to collect examples of those media, and only those media, from the 20th and 21st centuries just as from the 18th. However, in order to document design and its context, the emphasis must be on objects that will serve that function, no matter what those objects may be. As technology increasingly alters the physical world around us, those of us who collect the artifacts of the past and present are faced with an adjustment to the new world, just as those who create that world must alter their presuppositions. The concept of a "designed object" has changed, just as the definition of the work of art has changed in the modern era. One need only visit a New York salesroom to see that the definition of an original print has long since expanded to include photographically mass-produced works on paper.

The definition of the collection by media must be flexible. The European Department's holdings are largely 18th- and 19th-century decorative arts, and the collection of works on paper has begun its new life along traditional lines. A foundation has been laid for that collection and its expansion, but should museums collect only the products of an increasingly outdated

technology, documenting only the "Age of Paper"? Photographic periodicals are the chief documents of 20th-century design. Ornament prints *per se* are no longer being produced. Many designers work with a "mouse" in front of a computer screen rather than with a pencil and paper. Like it or not, a diskette of a computer-assisted design of an object will eventually find its place alongside the 18th-century drawings. Certainly, the death of prints and drawings, even those related to design, is probably not any more likely than the complete annihilation of the printed book. Nonetheless, it is clear that these traditional media will be of decreasing usefulness and interest for designers of the very near future. If "documenting design" is to be its purpose, the collection of works on paper will have to expand to include various extant categories of work as well as the products of media not yet invented.

CATALOGUE

Prints and drawings are divided into separate chronological sequences. A complete bibliography for each work has not been attempted. Standard oeuvre catalogues are cited where they exist. Abbreviated references are used throughout (see Works Cited). Measurements are in millimetres, height × width. Since many of the pieces have lengthy texts, only signatures, publication information, and brief titles have been recorded. The original orthography has been preserved. ROM acquisition information and accession numbers are followed by discussion of the work(s).

ARTISTS REPRESENTED

Aldegrever, Heinrich, No. 1
Auriol, George, No. 26

Berain, Jean, No. 13
Bickham, George, Junior, No. 16
Brisville, Hugues de, No. 12
Bry, Theodor de, No. 6

Chippendale, Thomas, No. 17
Cortona, Pietro da, No. 7

Delafosse, Jean-Charles, No. 43
Dugourc, Jean-Démosthène, No. 44

Eichler, Gottfried, No. 18

Fabergé, Peter Carl (workshop of),
Nos. 52, 53

Gabriel, Ange-Jacques, No. 40
Gherardi, Antonio, No. 7
Göz, Gottfried Bernhard, No. 45

Hoffmann, Josef, No. 54
Huquier, Gabriel (attrib.), No. 39

Indiana, Robert, No. 30

Jacquinet, C., No. 8
Jamnitzer, Christoph, No. 4

Kiss, Paul, No. 55

Larmessin, Nicolas de, II, No. 14
Le Pautre, Jean, No. 11
Le Prestre, No. 9

Mondon, Jean, No. 15
Moravek, No. 29
Moreau, Pierre (attrib.), No. 42
Moscoso, Victor, No. 31
Mouse Studios (Stanley Miller),
No. 33

Neufforge, Jean-François de,
No. 20
Nilson, Johann Esaias, Nos. 19, 46

Piranesi, Giovanni Battista, No. 21

Rädle, Christof, No. 34
Ransonette, Nicolas, No. 22
Robida, Albert, No. 25
Rubens, Peter Paul, No. 10

Schinkel, Karl Friedrich, No. 23
Stelletski, Dimitri Semionovitch,
No. 28
Süe, Louis, No. 27

Thiry, Léonard, Nos. 3, 5
Thornhill, Sir James, No. 36

Weisweiler, Adam, No. 41
Wilson, Wes, No. 32

1. Heinrich Aldegrever, German
(c. 1502–1555)

Two Spoons and a Hunting Whistle,
1539

Engraving
66 × 99 (plate)
Inscribed left: *1539 AG* [monogram]
Literature: Hollstein 1954, I:127; Bartsch
1803–1821, no. 268

Museum Purchase: European
Departmental Funds and Future Fund Today
991.69.1

NOTES
1. For Aldegrever and the decorative arts in
general, see Unna 1986:51–53.
2. Hollstein 1954, I:80; Bartsch 1803–1821,
no. 182.
3. Münster 1985:21–22.

Aldegrever's works are the primary examples of German Renaissance decorative style in prints, and exerted great influence over contemporary craftsmen as well. Not only were his figurative prints frequently copied onto objects of all sorts, he produced a number of engravings like this which are direct models for objects or ornament. This engraving shows his fully developed decorative style; in fact, it is the last Aldegrever print to represent an object rather than merely a decorative motif. It has been noted that the engraving doesn't just show a pattern for objects, but is a very three-dimensional picture of what appear to be real objects.[1] It is possible that Aldegrever may have trained as a goldsmith, as did many early engravers.

The two spoons depicted have silver or silver-gilt handles into which are fitted wooden or horn spoons. The short handle was meant to be held in the fist, rather than in the fingers as is our modern custom. Longer handles became the rule only with the advent of lace cuffs in the 17th century. It is usually suggested that the folding handles indicate that the spoons are for travelling or hunting, thus explaining their combination with the whistle. It may also be that this feature simply allowed one to fit the spoons neatly into a carrying box or pouch, or enabled them to fit more compactly into a *nef,* the locked container on the table that held one's personal serviette, spices, and utensils. During the 16th century, it was still the practice to bring one's own eating utensils to a meal—even as a guest. Luxury spoons would still have been regarded as a very personal belonging. Spoons as elaborate as these two, which outshine nearly all surviving spoons of the period, could have been seen as a sign of rank for a very wealthy, probably royal, personage.

The hunting whistle with which the spoons are combined is itself a magnificent example of German Renaissance decorative style, with profile heads on the medallions and a foliated dolphin head holding the mouthpiece. The clear, planar style of the decoration is typical of Aldegrever's mature style. The whistle, which again is more luxurious than surviving examples, is an object of great status. In his 1536 portrait engraving of Jan van Leyden,[2] the leader of the short-lived Anabaptist kingdom in Münster, Aldegrever shows his subject wearing a very similar whistle along with a great deal of other jewellery. It has been speculated that Aldegrever intentionally showed him as "dressed beyond his station," taking on aristocratic appearance to which he was not entitled.[3] Thus, the combination of the whistle and the ornate spoons may be understood not merely as a functional group, but as the very embodiment of regal luxury.

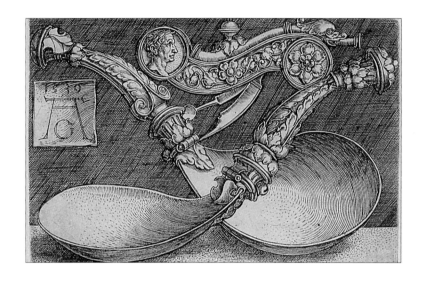

2. Unknown Artist, Italian

Grotesque Design, from *Leviores et (ut videtur) extemporaneae picturae quas grotteschas vulgo vocant . . . ,* c. 1540

Engraving
242 × 118 (sheet)
Museum Purchase
988.146.24

NOTES
1. The most penetrating analysis of the nature of grotesque ornament is Piel 1962.
2. New York 1981:60–61, no. 59. The set is cited as having a varying number of sheets. Guilmard 1880–1881:299 gives the total as 24; Berlin 1932, no. 533, as 18; and New York 1981 as "about 20."
3. See Dacos 1969 for a reconstruction of the originals.
4. Dacos 1969:32, figs. 35, 36.
5. Illustrated in *Illustrated Bartsch* 1978, vol. 30, nos. 467–490; Berliner and Egger 1981, I:46–47.
6. Geymüller 1887, no. 316.
7. Warncke 1979, II:79–80, nos. 642–683, with ills.
8. Frankfurt 1983, nos. 6a, 6b.

In the last years of the 15th century, artists in Rome began to visit the subterranean remains of the Golden House of Nero to view the surviving wall paintings. Because of their subterranean location in a grotto, these paintings were called *grotteschi,* from which their English name, "grotesque," is derived. The influence of these ancient grotesques on Italian Renaissance artists was a crucial element in the history of Western ornament. Grotesque ornament is based on the vocabulary of forms in these ancient decorative paintings, including fantastic creatures and fanciful classical architecture. Of equal importance is the logic of pictorial construction characteristic of the grotesque.[1] The norms of realistic images are subverted: three-dimensional figures stand on two-dimensional lines and architectural constructions rest upon a single point. In this example, lions, leopards, and snakes are supported by single lines while ducks swim in mid-air. In this manner, the grotesque liberated ornament from the purely two-dimensional realm of decoration.

This print comes from a set of twenty engravings, which are titled on the first sheet "Light and (as can be seen) extemporaneous pictures, commonly called grotesques."[2] They are similar in composition to the original paintings in the cryptoporticus of the Golden House. Most of the artists inspired by these paintings took individual motifs to use as friezes or vertical ornament, but very few retain any sense of the *mise-en-scène* of the figures or architecture. One very influential motif in this print is the stage-like arcade with a central figure. This element, which focuses the juxtaposition of two- and three-dimensional space, remained a constant in the vocabulary of the grotesque, becoming a hallmark of the compositions of Jean Berain, who brought the grotesque back into prominence in the late 17th century (see No. 13).

The set retains something of the sketchy execution of both the original paintings and the drawings made after them by Renaissance artists.[3] Indeed, the *Leviores* is strikingly similar to a group of drawings in Florence after the original paintings.[4] This authenticity may account for their popularity, as evinced by numerous 16th-century copies of the set. After their creation by an unknown artist about 1540, a set of copies of the entire group by Enea Vico was published almost immediately by Tomasso Barlacchi, dated 1541.[5] Vico's engravings were copied in France by Jacques Androuet Ducerceau in the 1550s.[6] Ducerceau published a second edition in 1562 and his set was itself copied by Johann Sibmacher of Nuremberg in a set published by him in 1594, and republished by Domenico Custos of Augsburg, before his death in 1612.[7] Another set of Italian copies was issued in 1602.[8] This is a particularly striking example of the power of printmaking to disseminate design ideas, as well as of the practice of ornament printmakers to plagiarize shamelessly any composition they felt was marketable.

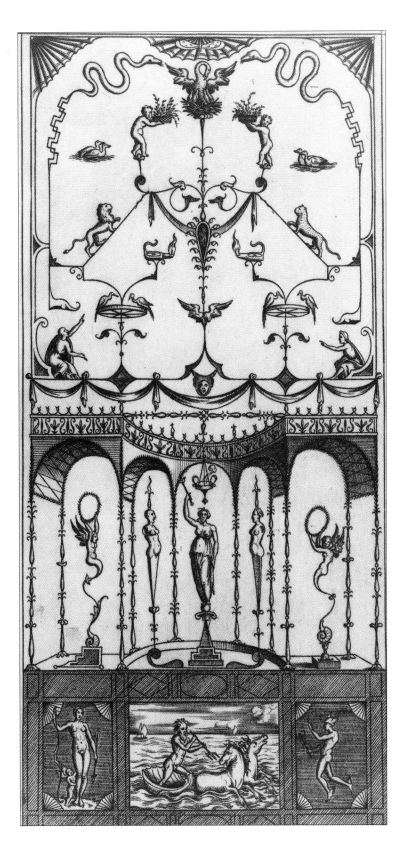

3. Léonard Thiry, Flemish (d. 1550)
Engraved by René Boyvin, French
(1525–1598)

Saturn, c. 1560

Engraving
171 × 100 (sides trimmed within platemark)
Inscribed below, in image: *Leonardus
Theodoricus Inventor;* below image: *Quid
prodest Saturne pater deglubere natos*
Literature: Inventaire XVIᵉ siècle, I:192, no. 1.
State I of II

Museum Purchase
988.146.22

From a set of sixteen panels with pagan divinities, this engraving clearly shows the influence of Italian ornament, in this case, the grotesque, on Fontainebleau designers (see No. 5). Classical themes and motifs drawn from ancient art are mixed with elements such as the mask with horns and eyeglasses in the centre. The mask resembles the type of northern design occasionally encountered in 16th-century grotesque armour.

It has been suggested that the set does not merely show a divinity in each print, but that each image refers to sacrifice to the gods. In this example, the small oval "reliefs" at each side of Saturn show sacrifices: one with a smoking altar and the other with a sacrificial bull. Additionally, the child being consumed is in some sense an offering to Saturn. *Saturn* is the first sheet from the set and as such bears the signature of Thiry. A later edition was altered to change the name of the inventor to "Rous Floren," or Rosso Fiorentino, whose fame was more lasting than Thiry's.

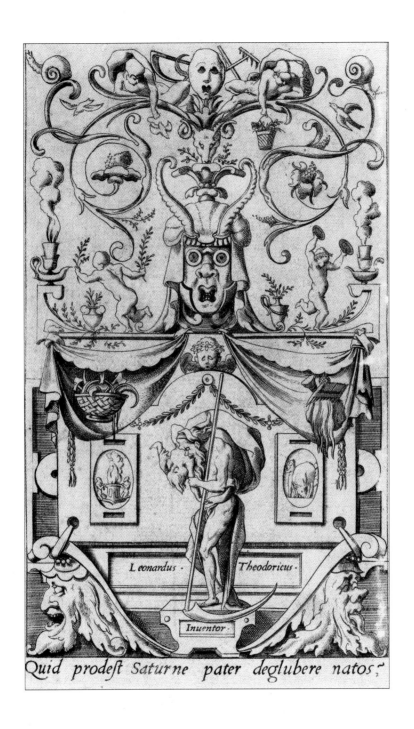

Leonardus · Theodoricus ·

Inuentor ·

Quid prodeſt Saturne pater deglubere natos⸗

4. Christoph Jamnitzer, German (1563–1618)

Grotesque with Mask and Elephant, from *Neuw Grottessken Buch,* Nuremberg, 1610

Etching
188 × 150 (plate)
Literature: Warncke 1979, II, no. 960

Museum Purchase
988.146.23.1

Jamnitzer was a highly successful goldsmith in Nuremberg, who came from a family of celebrated goldsmiths including his grandfather, the renowned Wenzel Jamnitzer. He makes clear in the preface to his pattern book that he intends it to be of interest to anyone who loves art and of service in helping young artists learn to draw. Although this composition is apparently of his own invention, Jamnitzer borrowed freely from other designers, especially Virgil Solis and Jost Amman.[1]

In its finished version, the book was divided into three sections, each with a title page that seemed to refer to one aspect of the origin or essence of the grotesque: in ancient art, Netherlandish or fantastic ornament, and finally German ornament, or the grotesque motifs drawn from the natural world.[2] However, as is common with such collections of patterns, the book was apparently assembled over a period of time. In the original complete order of the etchings, as postulated by Warncke,[3] the various types of images are fairly evenly distributed throughout the book, so that the title pages do not relate to the contents.

Some of the designs are not really grotesques at all, but just small oval compositions with tritons and dolphins. Others are not only bizarre but seem to suit the 20th-century meaning of "grotesque." Many of the pieces, like this one with its tiny elephant, seem to be meant as visual jokes. Jamnitzer prefaces each book with the same poem, which has a rather humorous air, summing up his approach to the subject in a nearly untranslatable motto: *Dann Kunst bleibt Kunst/ist doch zletzt Dunst* (Art remains art, it is all vapour anyway).

Designs similar to the grotesques of this style were incorporated into Jamnitzer's metalwork, in plastic form or as lightly punched decoration, often in contexts that seem quite odd. For example, in 1602 Jamnitzer made a silver-gilt basin[4] for Emperor Rudolph II with a scene of the Triumph of Amor in classical trappings as sculpted decoration in the centre. Around the rim are mythological scenes separated by grotesque decoration in the style of this print, which to modern eyes appears absolutely unclassical. It is necessary to realize that this combination was appropriate to Jamnitzer in order to understand his concept of the meaning of this type of decoration.

NOTES
1. These instances are enumerated in Juchheim 1976.
2. As proposed by Jamnitzer 1610:14–19.
3. Warncke 1978; Warncke 1979, II:98–102.
4. Vienna 1991:79–97, no. 5, ill. 72. The ewer that accompanies the basin shows similar grotesque motifs in three dimensions.

5. Léonard Thiry, Flemish (d. 1550)
Engraved by René Boyvin, French
(1525–1598)

*Jason Killing the Dragon who Guards
the Golden Fleece,* from Jacques
Gohory, *Livre de la conqueste de la
Toison d'Or,* 1563

Engraving
156 × 230 (plate)
Inscribed above centre: *10;* below left: *B*
[monogram]
Literature: Inventaire XVIᵉ siècle, I:176, no.
10. State II of III

Museum Purchase
988.146.20

In format, this print is based on the plasterwork executed at Fontainebleau by Italian artists in the employ of Francis I. The Gallery of Francis I, the King's Chamber, and the Chamber of the Duchesse d'Etampes feature decoration consisting of large horizontal paintings framed by elaborate three-dimensional stuccowork composed of strapwork (an ornament which supposedly resembles cut and overlapping straps of leather), surrounding symbolic objects and allegorical figures. This combination was first used at Fontainebleau in the plasterwork designed by Rosso Fiorentino and Francesco Primaticcio from 1531 in the Gallery of Francis I and several other rooms.

The mannerist style developed by the artists at Fontainebleau is particularly denoted by this type of ornament, as well as by the use of elongated human figures and complex, allegorical subject matter. All of these elements are well represented in this engraving from Thiry's series of scenes from the story of Jason. The Fontainebleau ornamental style was spread quite effectively across Europe via the numerous prints made by artists in the circle, primarily etchings, which are interesting for style but somewhat amateurish in technique. As a professional printmaker, Boyvin is rather a different case. He probably came to Paris from Angers about 1545.[1] He did a number of engravings after designs for objects by Rosso, as well as narrative scenes and portraits. His highly polished engravings are one of the most important bodies of evidence for Fontainebleau style in decorative arts.

Thiry was Flemish. From 1536 until about 1542 he was active at Fontainebleau, where he learned the style from its two creators, Rosso and Primaticcio.[2] He is recorded in the account books of the king as having received a fairly high salary for his work in Fontainebleau, both as a painter and designer. Although composed in a format similar to that of the painted decorations of Fontainebleau (where the elaborate frame would be three-dimensional plasterwork), this set of prints does not seem to record a group of paintings. Such designs may also have been useful for tapestries, and they served as models for a number of pieces of Limoges enamel.[3]

The history of this set of twenty-six engravings is rather unclear. Since Thiry died in 1550 in Antwerp, the drawings must have been made before his departure from France. The preface to the book states that Jean de Mauregard had the drawings made and then had them engraved by Boyvin. There was apparently a considerable interval between those stages. While there are proofs from the plates before the numbers were added, it seems hard to imagine that such a large set of images from one narrative would have been widely published without an accompanying text. They surely were not made long before the Gohory text was added in 1563, although

even that text, issued in both Latin and French versions, is really just a five-page preface to the group. The engravings in the set in the Département des Estampes of the Bibliothèque Nationale, Paris, have additional text on the same sheet—a Latin or French quatrain printed from a separate plate, presumably changed according to the Latin or French editions.[4]

The set has been described in three states: before numbers, with numbers, and after numbers. However, this description is not complete.[5] The proof shown here would be from the second state (with numbers), yet within this state there are confusing variations. The ROM impression is numbered 10 at the upper centre. It is numbered in the plate as 11 in the bound set in the Victoria and Albert, and is number 12 in the Bibliothèque Nationale exemplar! Finally, an unbound set in the Victoria and Albert has proofs of several sheets with numbers, but from plates in extremely worn condition.

NOTES

1. For Boyvin in general, see Levron 1941.

2. For Thiry, see Levron 1941:30.

3. Paris 1987, no. 97.

4. The poem accompanying this image reads:

> Par tels assaults Iason va travaillant
> Le fier dragon de nuit et jour veillant
> Que d'un sommeil eternel la paupiere
> Il luy silla sans plus veoir de lumiere.

5. Paris 1987:97. Levron (1941:34) notes that there were many more than three states.

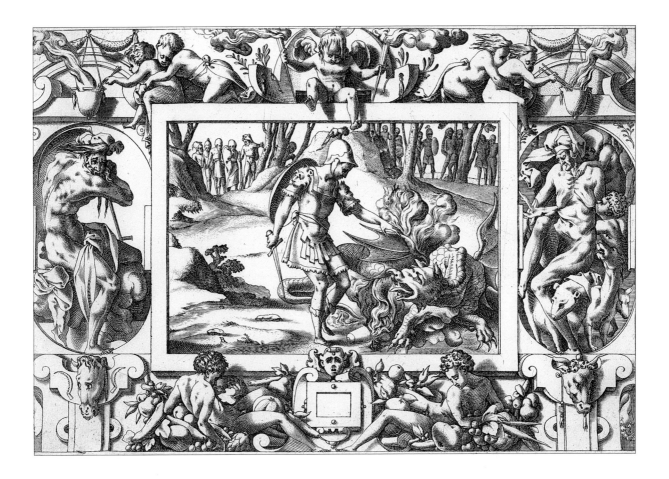

These two prints are patterns for the engraved decoration inside a footed metal bowl, or *tazza*. The use of minutely detailed figures set against a black background is typical of de Bry's decorative style in his many designs for engraved and nielloed metalwork of the second half of the 16th century. They are usually grouped with two similar designs with the heads of Folly and Charity to compose a "set" of four. Since the design with Charity is dated 1558, this date has been assigned to the other three by extension.[1] However, these four prints do not form a group. The format of the designs with Folly and Charity is not particularly similar to this pair, and it is questionable whether Folly and Charity are even meant as a pair.

Our two prints clearly do relate to one another as pendants despite a slight difference in composition. The central roundel of No. 6a shows William of Orange (1533–1584), leader of the Protestant rebellion of the North Netherlands against Spain, in profile as the *Hoopman van Weisheit* (Commander of Wisdom). The wide border is filled with grotesque motifs, foliate scrolls, and strapwork set with figures representing scenes of wisdom and rectitude. At the lower edge, de Bry shows the well-known incident of King Solomon deciding the fate of the disputed infant. The scene at the left appears to be Susanna and the Elders in contention before a ruler or judge. At the right, a man sits at table praying while tempted by Death and the Devil. The entire image is enhanced by commentary in French and Flemish.

Number 6b represents the Duke of Alba (1507–1584) as *Hoopman van Narheit* (Commander of Folly). He is surrounded, not by allegorical scenes of folly, but by grotesque figures resembling medieval drolleries. The figures satirize various human follies with a

6. Theodor de Bry, Flemish
(1528–1598)

Designs for Engraved Metal Bowls,
c. 1570

a. William of Orange as Commander of Wisdom

Engraving
122 diam. (sheet)
Inscribed centre: *DE HOOPMAN VAN WEISHEIT/ LE CAPITAINE PRUDENT/ THE DE BRI F ET EX* [with extensive text]
Literature: Hollstein 1949–1969, no. 178

Museum Purchase
989.215.1.1

b. The Duke of Alba as Commander of Folly

Engraving
121 diam. (sheet)
Inscribed centre: *DE HOOPMAN VAN NARHEIT/ LE CAPITAINE DES FOLLIE* [with extensive text]
Literature: Hollstein 1949–1969, no. 179

Museum Purchase
989.215.1.2

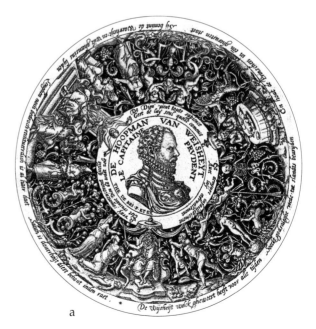

a

generous dose of sexual activity and flatulence. Because the Dutch rebellion was largely a struggle between Protestant and Catholic forces, it is not surprising to find a figure resembling the Pope under a baldachino at the lower centre, presiding over this realm of degrading human vices.

Although the Duke of Alba was a prominent Spanish general for several decades, he was first sent to the Netherlands as leader of the Spanish Army and Spanish Governor-General in 1567. This roughly coincides with the outbreak of the armed conflict and with William of Orange's ascent to the role of single leader of the rebellious Dutch. De Bry was Protestant and, as a result of the persecution of Protestants by the Spanish under Alba, was forced to leave Liège for Frankfurt am Main in 1570. Alba was withdrawn from his post in 1572. The engravings can therefore be fairly securely dated to the period 1567–1572. This cannot be checked against a chronological scheme for de Bry's stylistic evolution since his ornamental works are not in general dated or datable.

Hayward published several designs by Johann Theodor de Bry, the son of Theodor, for similar bowls or *tazze*. The designs are datable to the years around 1600 and show a much more pictorial approach to decoration.[2] Although Hayward maintains that "the fashion for engraved dishes hardly antedates the end of the sixteenth century," earlier bowls are known, such as the bowl in the Rijksmuseum by an anonymous Breda silversmith with a depiction of William Courten in jail, dated 1567.[3] Interestingly, the Courten bowl, like de Bry's designs, has contemporary political meaning, treated in a more straightforward manner.

NOTES
1. As in Hollstein 1954, IV, nos. 178–181; Paris 1987, no. 68. Warncke (1979, II, nos. 537–540) also describes the four as a single related group, but he reads the date on the engraving of Charity as 1588.
2. Hayward 1952:124–128.
3. Frederiks 1952–1961, III, no. 80, pls. 60, 61. The bowl shows Courten in prison, with an inscription commemorating his arrest by the Duke of Alba and subsequent escape to England aided by his wife.

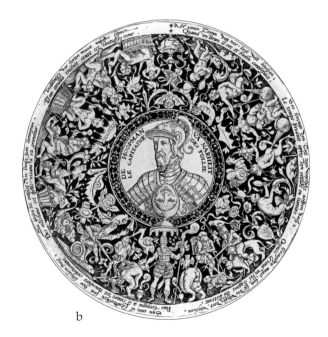

b

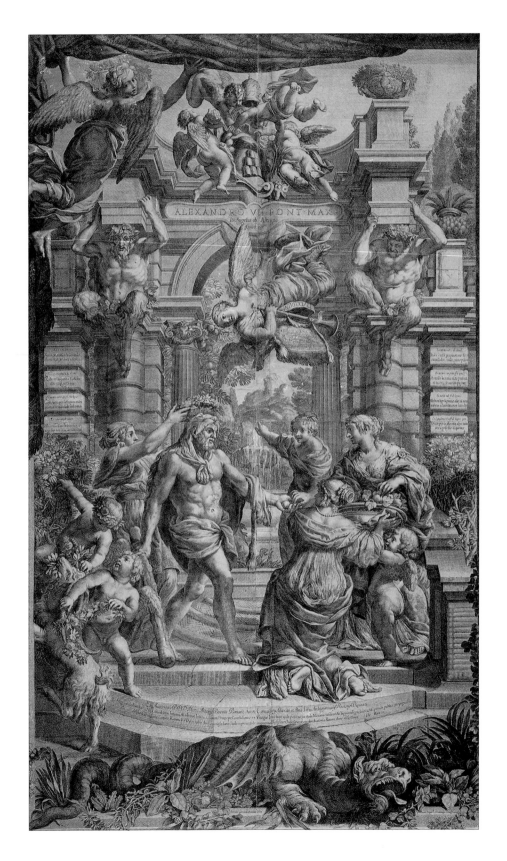

7. Pietro da Cortona, Italian
(1596–1669), and **Antonio Gherardi,**
called Reatino, Italian (1644–1702)
Engraved by François Spierre, French
(1639–1681)

*Thesis Sheet with Hercules in the Garden
of the Hesperides,* 1665

Engraving and etching
1552 × 998 (sheet)
Inscribed below: *Antonius Gherardus Reatinus
delin. Franciscus Spier Lotharingus sculp Rom . . .*
[with extensive text]
Literature: Wall 1987, A6

Gift of Professor Brian Mangren
991.194.1

Although largely forgotten now, in the late 17th century François Spierre was considered among the best engravers of his time.[1] Trained by François de Poilly in Paris, about 1660 he moved to Rome where he was active as an engraver of devotional images, title pages, and, as in this piece, thesis sheets. He was in considerable demand, being repeatedly commissioned by Bernini to make engravings of his sculptural work, including a print of the *Cathedra San Pietro* on a scale similar to this sheet. Bernini was apparently quite fond of the French style of engraving in *taille simple,* wherein volume is created by the use of supple undulating and tapering lines rather than by cross-hatching.

Along with its lengthy dedicatory inscription, the engraving contains eight "theses" put forth by Giovanni Angelo Altemps praising the efforts of Pope Alexander VII in the cultivation of oranges in Italy. The theses appear on the pilasters at left and right. The allegorical image shows Hercules achieving one of his "Twelve Labours," receiving the golden apples of the Hesperides, or daughters of the evening. The tree upon which the apples grew was guarded by the serpent Ladon, seen here slain at the lower edge of the image. It has been suggested that several aspects of the image may refer to the personalities involved.[2] The mountain in the distance, representing Mount Atlas, is similar to the mountain in the coat of arms of Alexander VII. The goat, prominently and gratuitously featured at the lower left, is the armorial animal of the Altemps, a family with long associations with the papal Curia. Finally, Gloria, swaying in the air in the middle of the image, has the arms of the University of Rome on the banner ornamenting her trumpet.

This proof of the print, like those in Paris, Rome, and Vienna,[3] has survived because it was never used for its ostensible purpose. The inscription on the step beneath the figures ends with an announcement of the date and time of the disputation. The engraver has left blank space after the month and day, filling in only the hour, 21. Presumably any copies actually used as announcements would have had the date filled in by hand. Copies so used would probably have perished in the process. It is unclear to what extent these prints were created as commemorations of the disputation rather than as announcements. Due to their large size, such prints issued to announce the holding of an academic disputation are often quite rare, as is this particularly magnificent composition.

As is traditional, the print is signed not only by its engraver, Spierre, but by the draftsman, Gherardi. Interestingly, Gherardi signs *delin* (for *delineavit* or *delineator,* drew or draftsman) as the creator of the drawing from which the print was made. While this does not rule him out as the inventor of the composition, it was customary

for the inventor to sign *inv.* or *invenit*. In fact, documentary evidence confirms that this is a composition by Pietro da Cortona. An entry in the diary of Carlo Cartari for 23 January 1666 records a great deal of information about the print.[4] Cartari tells us not only that Pietro designed the composition, but that he was given a watch brought by Altemps from France, with an estimated worth of 30 *scudi.* Gherardi, who probably made a finished full-scale cartoon from Pietro's sketch, received 80 *scudi.* Finally, Spierre, who is said to have worked for two years on the plate, received 600 *scudi* and an additional 60 *scudi* for engraving a smaller version of the same theme as a frontispiece to a book that elaborated upon the theses.

Pietro, like Bernini, was a multi-faceted talent who helped to create Baroque decorative style. The churning activity of parts of the image, such as the putti hoisting up the papal tiara, is typical of Pietro's ceiling frescos. A strong sense of receding space is created by the stone diaphragm arch around the composition, the angel drawing back a curtain at the upper left, and the dragon spilling out of the pictorial space at the lower edge. The satyrs, who function as caryatids, by their very realism act as the equivalent to the grisaille figures and three-dimensional stucco figures which are common features of Pietro's ceiling paintings. Continuing in the tradition of Caracci's Farnese Gallery, Pietro's style had great impact on Baroque architectural painting and the decoration of interior spaces. His dramatic effects are perfectly captured by the technical proficiency of Spierre's engraving.

NOTES
1. The discussion of this engraving is largely based on Wall 1987, especially pp. 56–58 and 188–189.
2. Wall 1987:189.
3. Wall (1987:188–189, no. A6), describes only one state.
4. See Worsdale (1983:69, n. 36) citing Cartari-Febei, b. 80 fol. 196v–196bis r, Rome, Archivo di Stato.

Nothing is known of Jacquinet apart from the engravings he provided for two sets of designs for the decoration of the metal fittings of firearms. He is presumed to have been an engraver of such decorated firearms by profession.[1] This book is prefaced by three engravings of scenes relating a young boy's first experiences as an apprentice in the trade. As they are rather cruder than the other engravings in the book, it has been speculated that they are not by Jacquinet. However, being narrative scenes instead of patterns, they are in such a different mode from the other plates that it is difficult to definitely answer this question.

The first three illustrations do give a humorous and charming little story of "Janot" becoming an apprentice gunmaker, each accompanied by a verse. In the first scene, he is apprenticed to the *arquebusier* with the assistance of a notary. In the second scene, exhibited here, the young apprentice is seen at the left in his first introduction to the shop, which is shown as a bourgeois artisanal workshop filled with the tools and products of the trade. Apparently on a second floor, the large windows open out onto a city street. The verse below explains that the apprentice must learn the names of all the tools. In the third scene, Janot is shown at work with two other men. The accompanying verse describes the routine work he must do as his first tasks, and how he begins to behave as an apprentice. All three of these scenes are surrounded with the insignia of various famed Parisian gun manufacturers.

8. C. Jacquinet, French (active 1660)

Interior of a Gunsmith's Shop with Makers' Insignia, from *Plusieurs models des plus nouvelles manieres qui sont en usage en l'art d'arquebuzerie avec ses ornements les plus convenables,* Paris, 1660

Engraving
121 × 137 (plate)
Inscribed in image: [names of various gunsmiths]; below: [eight-line verse]
Literature: Inventaire XVIIᵉ siècle, no. 3, describing state II of II

Museum Purchase
989.215.6

NOTE
1. For Jacquinet, see Inventaire XVIIᵉ siècle, V:448–449.

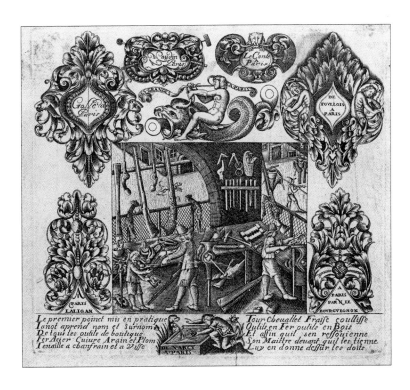

9. Le Prestre

Engraved by Johannes Looff, Dutch
(active 1627; died 1651)

*Memorial Portrait of Vice Admiral Joos
van Trappen*, 1629

Engraving and etching
479 × 365 (sheet)
Inscribed below: *Prestre Inventor: J: Looff
Sculp: Berch: Composius;* lower centre: *1629*
[with extensive text]
Literature: Hollstein 1949–1969, no. 3

Museum Purchase
989.196.1

This engraving by a silversmith is an excellent example of the principle that engraving in a printing plate is the same craft as decorative engraving in any other surface, with many of the same stylistic qualities. An engraved printing plate is simply meant to be inked and recorded on a piece of paper instead of preserved as an object. The engraver of this image, Johannes Looff, became a master silversmith in Middelburg in 1627 and was appointed seal engraver for the mint in Zeeland in 1634. Of his work, only a few engraved medals, three prints, and an engraved silver communion salver have survived.

The well of the salver, signed I. Looff 1631,[1] features an engraving of *Hanna Offering Her Child to the High Priest Eli* surrounded by an inscription in the same style of lettering used by Looff in the long inscription on the van Trappen portrait. The rim is decorated with ornamental strapwork in the style of Hendrik Janssen, including figures symbolizing the four elements and four cartouches with secular scenes. This strapwork is in the same style as the narrow strapwork surrounding the portrait of Admiral van Trappen in this engraving.

Looff was also a skilled engraver of silver portrait medallions, which were popular in the Netherlands during the late 16th and 17th centuries. The portrait of Admiral van Trappen in the engraving is executed in the same manner as these medallions. Thus the elements of the print relate to aspects of Looff's engraved work on objects. Surrounded by ornamental strapwork identical to his engraving in silver, the portrait and its frame are the equivalent of an engraved medal inserted into a larger context.

The calligraphic figures and border of the print are reminiscent not only of the taste for calligraphy on paper, but of its use to decorate objects. The crossover in the taste for this decoration can be seen in the work of Bastian Boers and Mathieu Petit, writing masters who worked as diamond-point engravers on glass as well as calligraphers on paper.[2] This is analogous to the work of Looff, who engraved both printing plates and silver objects.

NOTES
1. For the salver, which is now in the Rijksmuseum, see Hague 1952:6–7, no. 14; and Amsterdam 1979:72–73, no. 34, ill.
2. See Rietsema van Eck 1982.

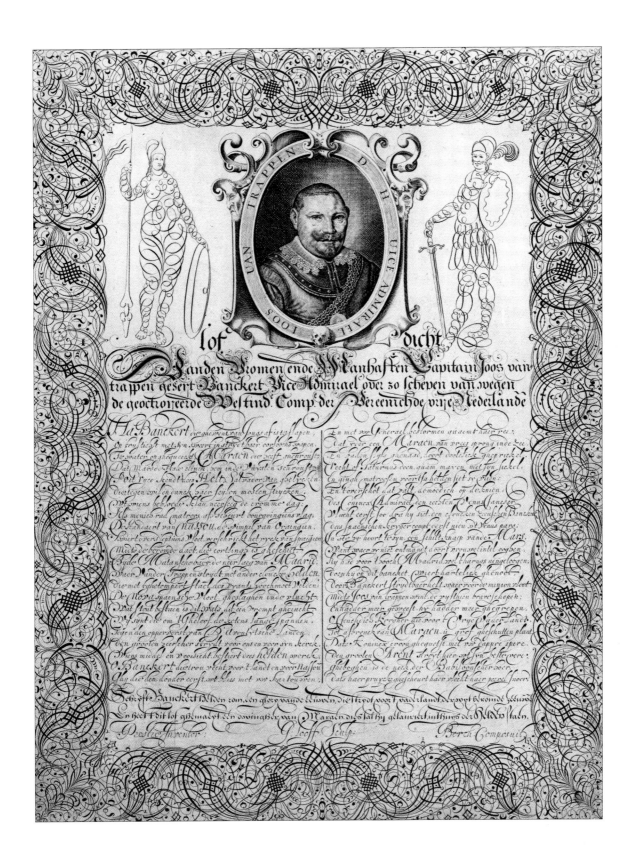

10. Peter Paul Rubens, Flemish
(1577–1640)
Engraved by Theodoor van Thulden,
Flemish (1606–1669)

Portico of the Austrian Emperors,
from Jan Caspar Gervaerts, *Pompa
introitus . . .* , Antwerp, 1641

Engraving and etching
537 × 845 (plate)
Inscribed above left: *pag. 43*; centre: *Porticus
Caesareo=Austriaca*; below: *P.P. Rubens Invent;
C. Gevartius epigraphis Illstrab; Theod. a
Thulden delin. sculps et excu. cum privilegio*

Museum Purchase: The Future Fund Today
990.137.1

One aspect of Baroque decorative arts which is all but impossible for us to imagine in the late 20th century is the state ceremonial. These multi-media events united literature, art, music, and theatre into a genre which, like opera, seems the very definition of Baroque style. It is difficult to overestimate the care and expense lavished upon such occasions. Their intellectual content certainly surpassed that of most modern ceremonials. One of the most artistically significant pageants was the ceremonial entry staged by the city of Antwerp for Ferdinand of Austria on 17 April 1635.[1] Ferdinand, a prince-cardinal and younger brother of the King of Spain, had arrived to take up his duties as Governor of the Spanish Netherlands. Such an entry was not merely mindless spectacle, but served a political purpose. As he was led through the city, the prince was shown the glorious history of the House of Hapsburg and reminded of the history of the city and of the mutual obligations and responsibilities of sovereign and subjects. All this was presented in the flattering, highly formalized conventions of allegory and emblem.

Antwerp's greatest artist, Rubens, was commissioned by the city magistrates to design the triumphal arches and "stages," or displays. Of the nine set pieces, the most elaborate was the Portico of the Austrian Emperors, which portrayed the greatness and universal hegemony of Ferdinand's forbears, the Hapsburg Holy Roman

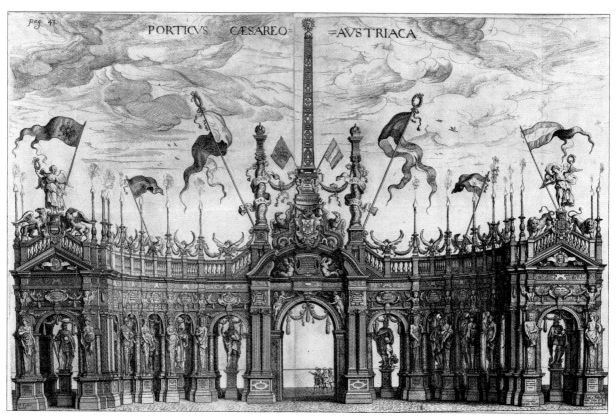

Emperors.[2] Although the subject matter is too complex to explain here, some description of what is portrayed in the etching is of interest. Thirty-one metres wide and twenty-three metres tall, the Portico was constructed of wood and painted in *faux marbre*. The arcade was dominated by twelve gilt statues of Holy Roman Emperors, each 2.5 m tall, alternating with painted cut-outs of Roman gods. The architrave was covered in red cloth embroidered with cartouches in silver thread and seraphim in gold. The three-dimensional balustrade was surmounted by painted cut-outs of laurel wreaths, palm branches, eagles holding banners, and flaming candles. At either end, a winged Victory holding a laurel wreath and an imperial banner was accompanied by two griffins.

Over the centre was a three-dimensional realization of the emblem of Charles V, with the pillars of Hercules shown as twisting columns bearing silver banners emblazoned with his motto, *plus ultra*. Above this was an obelisk crowned with the sun as a symbol of universal rule. The obelisk had sides made of coloured glass and was lit from within. If we add to this sight the sound of the trumpets and shawms which played as Ferdinand approached the portico, we can imagine the overwhelming effect of the procession, which lasted just over two hours and ended with a formal Latin oration followed by fireworks over the cathedral.

Shortly after the event, the city magistrates commissioned van Thulden, a Rubens follower who had worked on some of the paintings for the Entry, to produce a book commemorating the event with large illustrations and a text by Gervatius who had devised the original scheme.[3] The book was not completed until 1642.

The ROM exemplar is a set of the etchings without the text in a period binding. While there are a few minor variations in the plates (changed numbers and one altered inscription) which are normally found in the copies dated 1642, this is not exclusively the case. Some of the plates appear to have been printed on several occasions, but all of the plates were not necessarily reprinted at the same time.[4] It has been suggested that there were two editions (1641 and 1642), but this does not answer all questions since the book did not come onto the market until 1643!

The ROM volume, since it does not have the text, has no dated colophon. However, the addition of the vendors' address at the bottom of the page, "Prostant Apud Henricum Aertssens & Guilielmum Lesteenium," appears only in copies dated 1642.[5] It may be that after all the available copies of the text pages had been used, there remained additional copies of the illustrations which were thus bound separately for sale.[6]

NOTES
1. The definitive monograph on the Entry is Martin 1972.
2. For a description of the appearance and subject matter, see Martin 1972:100–131.
3. Martin 1972:225–227.
4. Plates 37 and 38 use the same plate to depict both front and back of the Arch at St. Michael's, changing only the picture in the top and the inscriptions. Therefore, when 38 was printed it was necessary to burnish out the traces of the title to be changed from 37. This is visible in the ROM copy. But, it is also visible that the ROM impression of 37 is printed from a plate which had already printed plate 38. Thus the plate was changed to 38 and then changed back again. Multiple printings definitely occurred, leading to the conclusion that van Thulden or one of the book dealers may have decided to increase the size of the edition.
5. Arents 1949:86–90 and 153–155, cat. 42–51.
6. Arents (1949:112–114) speculated that one of the publishers issued bound sets of the plates.

11. Jean Le Pautre, French
(1618–1682)

a. *Designs for Bed Alcoves*, from *Alcoves à la françoise. Nouvellement inventez et gravez par J. le Pautre* , 1678

i. Sheet 6
Etching
144 × 206 (plate)
Inscribed below right: *Fait par I. le Pautre*; below centre: *A Paris Chez N. Langlois rue St. Jacques a la Victoire/Avec Privilege du Roy*

Museum Purchase
988.146.6

ii. Counterproof
Etching
144 × 207 (plate)

Museum Purchase
988.146.14

b. *Designs for Urns*, from a set of six, c. 1661

i. Title page
Etching
231 × 160 (plate)
Inscribed below centre: *A Paris chez F. Poilly rue St. Jacques a l'Image St. Benoist, avec Privil. du Roy./J. le Pautre In. et fecit*

Gift of Mary F. Williamson
991.110.6.1

ii. Sheet 3
Etching
237 × 158 (plate)

Gift of Mary F. Williamson
991.110.6.3

NOTES
1. Thornton 1978:28–29.
2. Berlin 1939, nos. 358, 359.
3. Berlin 1939, no. 313.
4. Vases à l'Antique, Victoria and Albert Museum, E6608–6613-1908.

Although trained as a cabinetmaker, Le Pautre spent his life as a professional printmaker, producing over 2200 prints. Using etching rather than the more tedious medium of engraving, he was able to produce images for many uses, working for a number of different publishers, as well as publishing some of his own prints. His original designs provide an excellent sampling of Baroque style in France from the 1650s through the 1670s, including patterns for all sorts of decorative arts, primarily architectural or interior views and details.

Le Pautre's sets of bed alcoves illustrate a newly fashionable development in French interiors.[1] Named for supposedly different styles (*à la françoise, à la romaine, à la royalle*), the sets of alcove designs present a full range of ideal Baroque decorative schemes. Many have elaborate sculpted beds set in vast spaces. The richly carved decoration of the walls, the use of columns and heavy moulding, and the massive curtain in one half of the image in No. 11a are hallmarks of the Louis XIV style, created by Charles Lebrun and the decorators of Versailles. The use of vases to decorate the cornice of the alternative on the right side is an unusual touch, reminiscent of the contemporary rage for porcelain rooms.

Some of the designs are provided with figures depicting narrative events as part of the print; others, like this example, have just a few figures for scale. The title page to this set in the Victoria and Albert bears the publication line *Alcoves à la françoise. Nouvellement inventez et gravez par J. le Pautre 1678*. The year has been burnished out of the title page of the ROM's set; however, it still gives the publication credit as cited above, for Nicolas Langlois. Thus these proofs are probably from one of the collections of designs by various artists published by Langlois around 1700,[2] rather than from the large collection of 750 plates by Le Pautre reprinted and issued by Charles Jombert in 1751 as *Oeuvres d'architecture de Jean Le Pautre*.[3]

Exhibited here is a proof on which one side has been counterproofed. Although craftsmen and designers were expected to be able to imagine an entire symmetrical design from seeing only one half, this technique provides a full design of the alcove, perhaps meant to make it more comprehensible to the layman.

Le Pautre's designs for urns reflect the fantastic style of sculpted vases which had a tradition extending back to the early 16th century. Although shown as huge garden sculpture, they were related to smaller works in materials such as bronze. This set of six etchings, although undated, is virtually a continuation of a set published by Mariette in 1661.[4]

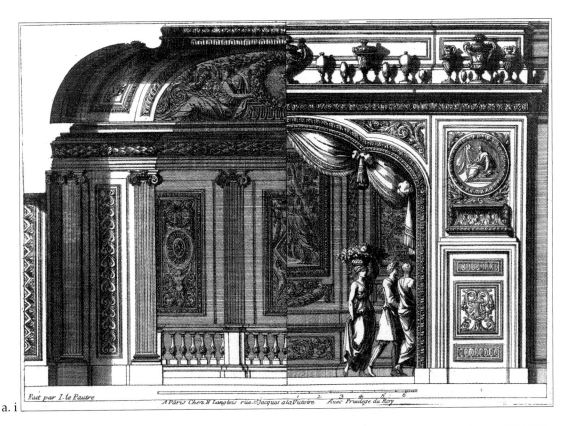

a. i

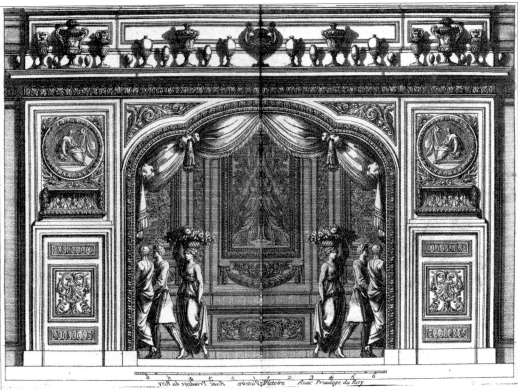

a. ii

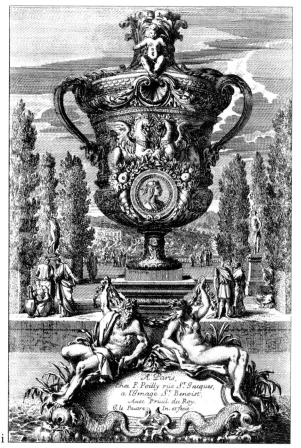

b. i

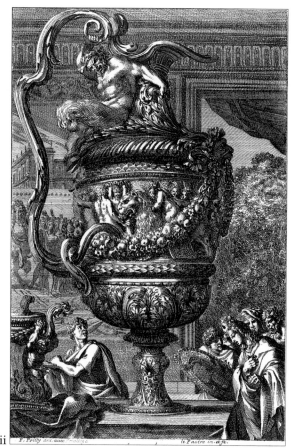

b. ii

12. Hugues de Brisville, French
(active c. 1663)
Engraved by Jean Berain, French
(1640–1711)

Design for an Escutcheon, from
*Diverses pièces de serruriers inventées
par Hugues Brisville*

Engraving
169 × 112 (sheet, irreg.)
Inscribed above right: *10*; centre: *BERAIN.
Brisville inventor*
Literature: Weigert 1937:19 [1]

Museum Purchase
990.104.1

De Brisville is known only as the designer of this set of designs for various pieces of metalwork, usually, like this escutcheon, intended to be executed in cut and engraved flat objects. His grotesque style of ornament has an almost late-medieval appearance with its cast of figures growing out of foliate spirals, the foliate mask at the lower centre, and the delight in the humorous aspect of the grotesque. Here, two dogs in the middle band of decoration appear to chase the vicious-looking hare who sits below, atop the intersection of two foliate scrolls. The skewed logic of the grotesque is seen in the hare, foreshortened but resting upon flat surface decoration, as well as in the ability of the band of bead-and-reel ornament to function as an impenetrable border between the dogs and the hare. The set is undated but must be from the early 1660s, as sheets 13 and 14 are signed by G. Ladame, who also did a portrait of de Brisville dated 1663. This puts the set into the early years of the career of their engraver, Jean Berain, who came from a family of gunsmiths and is thought to have worked in his youth as an engraver of metal gun parts.[2] Berain was the engraver and inventor of similar sets of designs for gun parts dated 1659, and it is presumably during this period and in the same milieu that he was in contact with de Brisville.

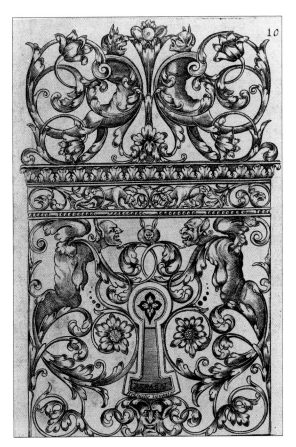

NOTES
1. Weigert 1937 lists this as plate 8 from the set, so there are obviously several states.
2. Weigert 1937, I:13.

13. Jean Berain, French (1640–1711)
Engraved by Jean Dolivar, French
(1641–1692)

*Grotesque Ornament with Enthroned
Female Figure,* c. 1690

Engraving and etching (printed after 1711)
333 × 257
Inscribed below: *Berain Invenit et delineat/D/
I. Dolivar Sculpsit*
Literature: Weigert 1937, II:116[1]

Museum Purchase
990.242.1

Appointed *Dessinateur de la Chambre et du Cabinet du Roi* in 1674, Berain became one of the most influential designers of the 17th century and gave his name to a style of grotesque ornament. He was called upon to design almost anything: theatrical costumes and settings, temporary contructions, boats, coaches, furnishings of all types, and eventually interiors. Beginning in the 1680s he issued engravings after some of his designs. The style of grotesque design for which he became known, with broad rectilinear bands out of which issue foliate scrolls, swept northern Europe in the years around 1700, and was used as two-dimensional decoration on virtually everything imaginable. In its most complex form, with fantastic figures and furnishings, it is the direct descendant of 16th-century grotesques.

After Berain's death in 1711, the copper plates of these designs went to his son-in-law, Jacques Thuret, who published a large collection of Berain's work.[2] This engraving comes from such a collection, in an early 18th-century binding, along with sets of prints from the 1670s after Georges Charmeton and Jean Cotelle.

NOTES
1. Weigert 1937 lists only one state, without the addition of the "D."
2. Weigert 1937, II:6–7.

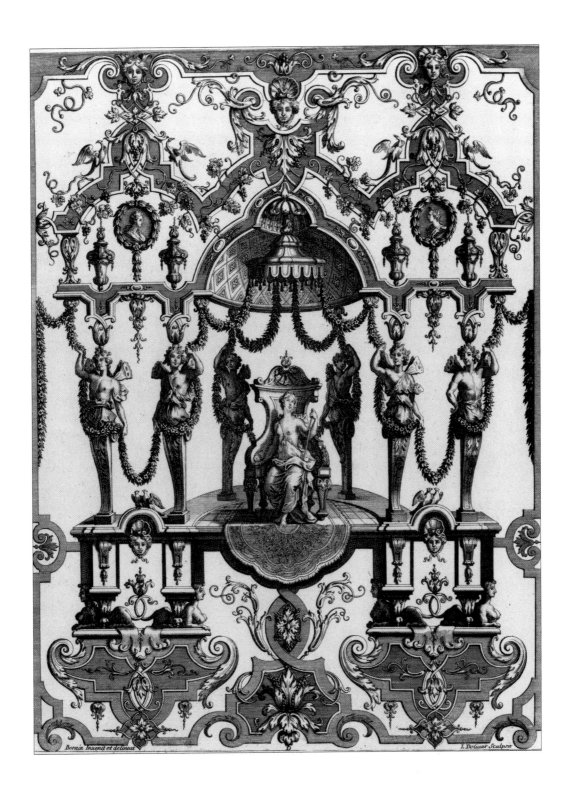

The goldsmith in this image is constructed out of objects related to his profession: the bows on his shoes are made of forks and spoons, his thighs are two chargers, and his hips are a silver console table with naturalistic horse's feet as legs. Numerous objects are displayed on the table, one of which is the wine cooler that, along with two small plates and a star-shaped medal, are the basis of his torso. His hat is a silver cage containing numerous small products of his craft.

Sets of images of occupations have a history extending back to antiquity, and such printed images were made as early as the 15th century. The first great example of a large cycle is the *Ständebuch*, with illustrations by Jost Amman to verses by Hans Sachs, published in 1568. Earlier examples use the professions as illustrations for concepts like the labours of the months, or as an opportunity to teach a moral lesson about the value of work in a good life.[1]

The set of professions invented by Nicolas de Larmessin,[2] represented here in a copy by Gerard Valck, has a different purpose. Neither the original French set nor its Flemish copy is accompanied by text. Rather, the purpose of the prints is to provide inventive and delightful embodiments of each craft, in the vein of the images illustrating sets of tradespeople's "cries," which were of continuing popularity from the late 16th to the 19th century.

Larmessin's conceit is to show each practitioner assembled from objects related to his or her trade. Although this is reminiscent of the symbolic figures in paintings by Arcimboldo, the conceit is more likely to come from the tradition of elaborate costumes for masques. Such novelty figures enjoyed great popularity in the 17th century. The original set is dated 1695 and Valck's copy would probably not be much later than that.

14. Nicolas de Larmessin II, French (c. 1660?–after 1716)
Engraved by Gerard Valck?, Dutch (1651/52–1726)

Costume of a Goldsmith, from a set of symbolic costumes of trades, c. 1700

Engraving and etching
282 × 195 (plate)
Inscribed below centre: *Habit d'Orfévre;* below right: *G. Valck, Ex: 5*
Literature: Hollstein 1949–1969:59, as Valck

Museum Purchase: Prints and Drawings Endowment
991.188.1

NOTES
1. As in the nearly contemporary set by Christoph Weigel, *Abbildung der Gemein-Nützlichen Haupt-Stände* of 1698, in which each image is accompanied by a moralizing poem.
2. Inventaire XVII^e siècle:12–86. See also facsimile, *Les costumes grotesques et les métiers de Nicolas de Larmessin, XVII^e siècle*, Paris, 1974.

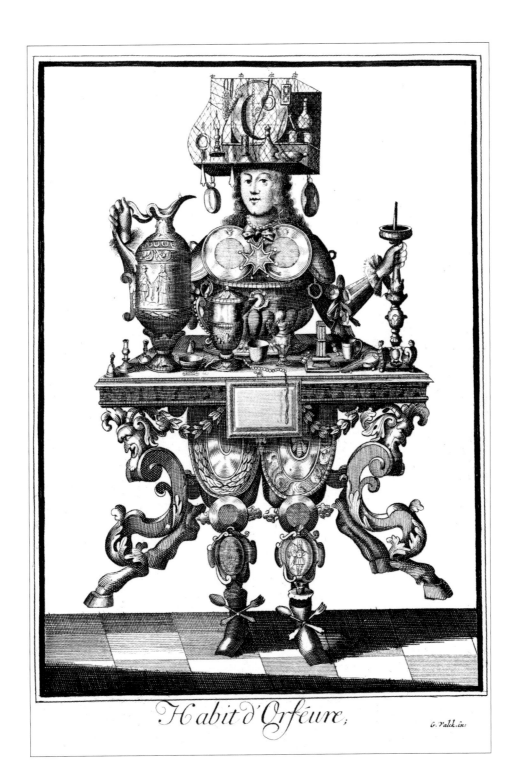

Habit d'Orféure;

G. Valck.éx:

15. Jean Mondon, French (active 1736–1760)

Etched by François-Antoine Aveline, French (1718–1780?)

Oriental Idol, from *Quatrième livre de formes ornées de rocailles cartels figures oyseaux et dragons chinois,* 1736

Engraving and etching
227 × 179 (plate)
Inscribed above left: *D;* above right: *2;* below: *Mondon le fils inv. A. Aveline Sculp/Avec Privilege du Roy*
Literature: Inventaire XVIII^e siècle, no. 6 (Aveline)

Museum Purchase
989.215.4

The fundamental development of French Rococo style in design, rocaille ornament, has been defined as the replacement of traditional individually articulated classical architectural forms, such as columns and pediments, by ornamental forms which have evolved to become structural and monumental in scale.[1] The cartouche and the shell form, once merely subsidiary elements of architectural decoration, become self-sufficient architectural or decorative forms. This development reaches its first full expression in the work of Juste Aurèle Meissonnier, published by 1734,[2] and at about the same time in prints after the designs of Jacques de Lajoüe.

In 1736, when Aveline published forty-two prints (six groups of seven prints) after the designs of Jean Mondon the Younger, this radical Rococo was still quite new. Little is known about Mondon; the only real source is the notice of publication of these sets in the *Mercure de France,* which describes Mondon as a *"Sculpteur en bijoux connu sous le nom de cizelure."* His designs continue the Rococo in the vein of Meissonnier and Lajoüe. The bat's-wing motif and curving architectural forms are the substance of the image. There is similarly little biographical information about Aveline, the son of an engraver. The prints after Mondon are the only ornament pieces in his oeuvre, which otherwise consists mostly of portraits and book illustrations. By 1759, he had moved to London where he stayed until his death, thought to have been in 1780.[3]

Mondon's designs take a further step by including people moving among these rocaille structures as if they were huge garden ornaments.[4] Although many of Mondon's scenes have figures in contemporary European dress, some figures are so-called chinoiserie. As in this design, the element of the exotic and the bizarre, which was permissible in a scene of Chinese subject matter, provides a rationalization for the daring forms of the new style. The huge conglomeration of ornamental motifs that dominates this picture is given validity by being the "throne" of an oriental idol. Of course, the only element with even a remote resemblance to anything actually Chinese is the hat of the standing figure to the lower right. The bird at the bottom of the composition is an extravagant version of the hoho bird, a recurrent image, especially in the work of English chinoiserie designers such as Chippendale (No. 17).

NOTES
1. See Bauer 1962, especially pp. 16–32.
2. Nyberg 1969:33–34.
3. Inventaire XVIII^e siècle, I:285.
4. Bauer 1962:37.

Mondon le fils Inv.

Avec Privilege du Roy.

A. Aveline Sculp.

Bickham's *The Musical Entertainer* was published twice monthly from 1734 to 1739 in numbers of three or four sheets, for a total of one hundred song sheets. The decorative headpieces for the songs were one of the first appearances of French Rococo style in English art. It seems particularly appropriate that the style would have been popularized in connection with light music and entertainment.

Snodin has pointed out that many of Bickham's compositions are closely based on French originals, either copying single prints or combining motifs from several printmakers.[1] While precise sources of these two images have not been identified, they both show the fashionable Rococo forms taken from leading French designers such as Lajoüe and Meissonnier. The use of the large ornamental archi-

16. George Bickham, Junior, English (1706?–1771)

a. *The Inamourd Swain,* from *The Musical Entertainer,* 1737–1739

Engraving and etching
325 × 198 (plate)
Inscribed above right: *37;* below image: *G. Bickham Junr. Sculp.*

Museum Purchase: The Helen Margaret Langstaff Bequest
986.153.2.3

b. *The Generous Repulse,* from *The Musical Entertainer,* 1737–1739

Engraving and etching
327 × 198 (plate)
Inscribed above right: *99*

Museum Purchase: The Helen Margaret Langstaff Bequest
986.153.2.7

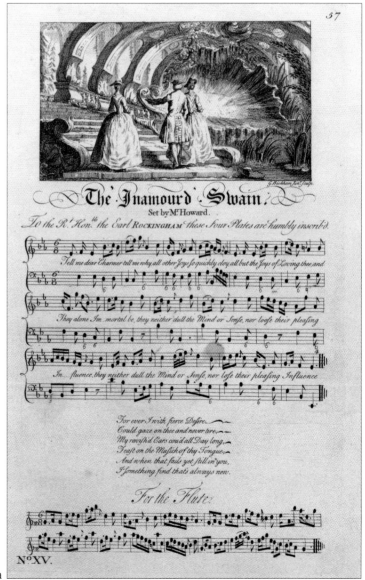

42

tectural motif as a piece of garden decoration with figures in contemporary dress is based on the designs of Jean Mondon, published in 1736 (No. 15).

While many of the scenes are adapted to suit the songs they illustrate, there often seems to be only superficial connection between the subjects of the songs and the images chosen to enliven the sheets. Elegant love songs are combined with elegant scenes. Still, one can't help but notice that "The Generous Repulse" is accompanied by an image of a young man making his plea to a woman, the dog attempting to jump into her lap providing an obvious sexual allusion.

NOTE
1. Snodin 1983 cites copies of Watteau, Lajoüe, Mondon, Boucher, et al.

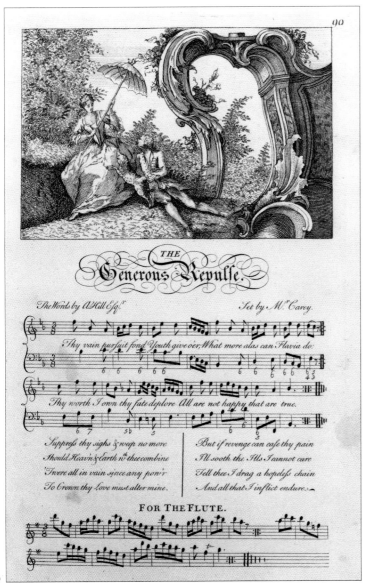

17. Thomas Chippendale, English
(1718–1790)

a. *China Case*, Plate CVIII from *The Gentleman and Cabinet Maker's Director*, London, 1753
Engraved by Tobias Müller, German, active in England (1744–1790)

Engraving and etching
223 × 349 (plate)
Inscribed below: *T. Chippendale inv et del. Pub. according to Act of Parliam. 1753 I.S. Muller sculp.*

Museum Purchase
992.72.6

b. *Frames for Marble Slabs*, Plate CXLVIII from *The Gentleman and Cabinet Maker's Director*, London, 1754
Engraved by Matthias Darly, English (active 1753–1778)

Engraving and etching
224 × 350 (plate)
Inscribed below: *T. Chippendale invt et del. Publish'd according to Act of Parliament M. Darly Sculp.*

Museum Purchase
989.84.4

Chippendale's *Director* is the pattern book *par excellence*.[1] He is thought to have published the *Director* in order to draw attention to his workshop at the time of a major expansion. He may have been trying to obtain commissions directly rather than as a sub-contractor for other decorators. As is common in the history of pattern books, the *Director* was intended for two related readerships: Chippendale's colleagues in various trades, and the people of wealth and taste who were his potential patrons. The list of subscribers to his first edition indicates that he was quite successful in appealing to both groups, although Gilbert has shown that 65 per cent of the subscribers were tradesmen.[2] Although Chippendale's patterns are quite specifically for furniture, subscribers included those involved in many trades other than cabinetmaking, such as enamellers, engravers, watchmakers, and jewellers.[3]

The scale of the *Director*, with 150 large plates (of which the ROM owns a large selection), relates it more closely to architectural treatises than to the small groups of pattern sheets produced as models for craftsmen. Chippendale was quite aware of this connection and tried to justify it in his preface. He also chose to begin, as did many books on architecture, with an exposition of the five classical orders. In fact, his first eight plates are instructions for drawing the orders, plagiarized from James Gibbs' *Rules for Drawing the Several Parts of Architecture* of 1732. Like architectural books, it progresses through various types of objects and styles, ending with those that are more purely ornamental models for carvers.

His notes to the plates again seem to be addressed to both craftsmen and patrons, as he provides some technical detail on how the piece is to be made and brags about how beautifully he has executed, or could execute, the finished piece. He describes a piece of cabinetry similar to the China Case, No. 17a:

> [This] . . . is a China Case with glass in the doors and ends. You have two different feet, which with the rail, are all cut through. This design I have executed with great satisfaction to the purchaser. The mouldings and dimensions are all fixed to the drawings. This canopy projects more at the ends than in front, therefore the workman must have recourse to Plate LIX, Fig. I for the proper directions to execute it.

The ROM coincidentally possesses an English cabinet of about 1760 (ROM 923.20.1) that exactly follows this pattern, with the alternate design for the leg. In designs for more purely ornamental pieces such as the elaborately carved console tables in No. 17b, Chippendale did not attempt to provide construction guidance, advising only, "I refer to the taste and judgement of the skillful workman."

China Case.

Chippendale inv et del.　　　Pub. according to Act of Parliam 1753.　　　J.ᵗ Miller sculp.

a

Frames for Marble Slabs.

T. Chippendale inv.ᵗ et del.　　　Publish'd according to Act of Parliament.　　　M. Darly sculp.

b

Both of these designs are examples of Chippendale's role as one of the chief exponents of chinoiserie style in English furniture. Gaining popularity in the 1740s, during the period of the genesis of the designs in the *Director,* the most elaborate and fanciful Chinese motifs were applied to furniture. In No. 17a the fretwork associated with Chippendale's chinoiserie is applied to the doors and legs, along with fanciful bells attached to the projecting ribs of the pagoda top. Number 17b demonstrates the range of elaboration possible in carved furniture in the Chinese style. The design at the top left is just a Rococo console to which a vaguely Chinese-looking finial has been added. In the more adventurous design at the lower left, the architectural elements of the table have been almost completely eliminated in favour of pictorial motifs. In the completed table, two trees would form the legs of the table, joined by a stretcher made out of twin Chinese footbridges leading to the central image of a Chinese god or "pagod."

NOTES
1. This discussion of the *Director* is based on the detailed history available in Gilbert 1978, I:65–124.
2. Gilbert 1978, I:71.
3. Gilbert 1978, I:69.

18. Gottfried Eichler, German
(1715–1770)
Etched by Jeremias Wachsmuth,
German (1711–1771)

Two Rustic Couples, from *Diversi
Pensieri*, a set of four, c. 1755

Etching
192 × 290 (plate)
Inscribed below centre: *No. 154*; below right:
3 [German and Latin captions]
Literature: Berlin 1939, no. 167, 1

Museum Purchase
988.146.1.2

This sheet with two patterns comes from a set with an Italian title page reading, *"Diversi Pensieri di Godofredo Guercino, intagliato, in rame, da J. Ceranimo e dato in luce per Gio Giorgio Hertel in Augusta"* (Diverse Thoughts, by Godofredo Guercino, etched in plate by J. Ceranimo and published by Johann Georg Hertel in Augsburg). The two amorous scenes show rustic couples ensconced in trees. The trees could be described as stylized natural forms or, conversely, as naturalistic "blasted tree" rocailles. In the scene at the left, the young man smokes a pipe, perhaps to suit the design for a tobacco box. At the right, an age-old expression of affection, stroking the chin, is shown. Both vignettes are set on abstract islands of space, in the manner popularized in Huquier's engravings of the 1730s after Watteau. As with many ornament prints, these images are ambiguous in nature. They are not models for specific objects, yet do not seem to be fully self-contained works of art.

Augsburg had a strong tradition of printmaking, which began in the 15th century. Like the city's famed silver products, printed images, among them ornament prints, were created in vast quantities in Augsburg as export articles. Augsburg publishers, who were probably the driving force behind the trade, commissioned artists to copy French ornament prints or to create original sets in the

Ich Gieb ein Pfeif Toback, bey holden Amors blicken,
Oscula fumanti non despicit atra Tobaco.

N⁰. 154.

Darein ein grober Baur, sich gleichfals weiß zu schicken.
Rustica amans, sic mollit amor praecordia dura.

3

Augsburg version of recent French style. It was through ornament prints as much as three-dimensional objects that the robust South German version of Rococo became known disparagingly as "Augsburg taste."

The use of Italian for the title of the set is puzzling. Guercino and Ceranimo are not the names of Italian artists,[1] but Italian pseudonyms for Gottfried Eichler and Jeremias Wachsmuth. There are no other examples of an Augsburg publisher of the period using an Italian title to give an air of style and fashion to a set of ornament prints. Paris was the centre of style, and German print sets were given French titles if anything other than German was used. Augsburg had a centuries-old tradition of trade with Italy and it may be that, if the Italian title is anything other than a jest, it was intended to aid sales in northern Italy.

The popularity of Rococo in South Germany caused Rococo patterns to be produced in Augsburg from the 1730s into the 1760s, well after their popularity had faded in France. Although this characteristically Augsburg Rococo sheet is comparable to French work of the 1730s, it dates instead from the period 1755–1760. Eichler and Wachsmuth were also engaged to work together by Hertel on his edition of Ripa, which is in a similar style and dates from the period 1755–1759.[2]

NOTES
1. Thieme-Becker 1907–1950, VI:290 and XV:220, and Berlin 1939, no. 167, notwithstanding.
2. Ripa 1970:18. The number 154, the series number from Hertel's publishing house, is not of much help in dating because Hertel's numeration is not a reliable chronological index. The second half of this set (Berlin 1939, no. 167, 2), made up of four sheets that continue this group, does not follow it immediately in the numeration, but is number 159.

19. Johann Esaias Nilson, German
(1721–1788)

a. *Rococo Structure with Figures Representing Coffee, Tea, and Tobacco,* Title page from, *Caffe The und Tobac Zierathen,* c. 1755

Etching
183 × 283 (plate)
Inscribed in image: *Caffe The und Tobac Zierathen;* below right: *J.E. Nilson inv. sculps. et excud. Aug. Vind.*
Literature: Schuster 1936, no. 52.1

Gift of Mr. and Mrs. Peter Moorhouse in Memory of Helen Tudor Moorhouse
990.104.6

b. *Pier Glass with the Four Stages of Life,* from a set of four Rococo designs, c. 1755

Etching
271 × 200 (plate)
Inscribed below: *Trumeau de Glace, Orné avec les quatres parties de la Vie humaine*
Literature: Schuster 1936, no. 76

Gift of Mr. and Mrs. Peter Moorhouse in Memory of Helen Tudor Moorhouse
990.104.4

c. *Chimneypiece with the Four Seasons,* from a set of four Rococo designs, c. 1755

Etching
263 × 191 (sheet)
Inscribed below: *La Cheminée Orné avec les quatre parties de l'année*
Literature: Schuster 1936, no. 77

Gift of Mr. and Mrs. Peter Moorhouse in Memory of Helen Tudor Moorhouse
990.104.5

Nilson was the leading designer and engraver of ornamental prints in 18th-century Augsburg, although he produced few prints that are either patterns for objects or abstract ornament to be applied to objects. Most of his work has a highly ornamental quality, but at its core is a narrative or at least figural scene. South German Rococo has been proposed as a critical phase in the evolution of our modern concept of images and ornament.[1] If that is so, Nilson is the only Augsburg printmaker/designer who was quite self-consciously aware of questions related to the nature of images and ornament.

His set of *Coffee, Tea and Tobacco Decorations* is as close as he came to providing obvious models. The three sheets of patterns following the title page each show four rectangular compositions of figures and rocaille formations appropriate for decorating various objects associated with these products, which were still regarded as exotic imports. The title page is a *trompe-l'oeil* conceit, as if it has been pulled to one side to reveal the sheet of patterns below. Children dressed as adults were a favourite motif for Nilson and Rococo designers in general. These four embody various associations with the three substances. At the left, a dreamy little boy sits in the melancholic torpor often attributed to smokers in such decorative pieces. The "Chinese" figure stands next to a group of exotic products from the East and the Indies while the two figures representing European women boil water for tea or coffee.

The set of four designs that includes the pier glass and chimneypiece shown here is his only set that actually shows designs for three-dimensional objects. The images refer to the standard form of pattern designs, but deliberately defy the requirements of their putative function as model sheets by conflating the representation of stone or plaster with the representation of living beings. The small figures symbolizing the Four Seasons on the chimneypiece are part of the cleverly manipulated ambiguity of the image. For example, if the chimneypiece design were a straightforward pattern, all four figures would need to be placed so that they could actually be realized in plasterwork figures. Clearly, Nilson's little figure of Winter, warming himself by the fire, has taken on life. By extension, the other three figures must not be part of the carved decoration, but are living figures, perched upon the chimney. The merger of the abstract sphere of decoration with the surrounding reality is fundamental to the aesthetic of Rococo decoration.

The fanciful construction in No. 19a is architectural at the sides but in the middle metamorphoses into a rocaille form. It seems to be a natural phenomenon, an "earth rocaille" with allusions to natural substances in passages that recall shells, peeling bark, and foliage. This type of rocaille and the nature of the building as a ruin have been defined as essential characteristics of German Rococo ornamental style.[2] In contrast, the pier glass and the chimneypiece

a

b

c

50 Johann Esaias Nilson

are more strictly architectural, with the solid parts of the design representing abstract forms. However, Nilson's deft touch is evident in his representation of the decorative elements of flowers, foliage, the sun, and the figures both as real and as part of the suggested design. Typical of Augsburg Rococo ornament prints, all three works give the lower edge of the setting an irregular, three-dimensional profile. Against the white of the paper, the scenes seem to float in mid-air. This heightens the viewer's awareness of the plane of the paper and the artificiality of the pictorial language.

NOTES
1. Bauer 1962 and Harries 1983.
2. Bauer 1962: 56–57.

20. Jean-François de Neufforge,
French (1714–1791)

Designs for Chairs and Tables, 1768,
from *Recueil élémentaire d'architecture
composé par le Sieur de Neufforge*,
1757–1780

Etching
463 × 228 (plate)
Inscribed above right: *3* [identification of
objects]; below: *Composé et gravé par
Deneufforge/A Paris chez l'Auteur rue St.
Jacques au Chariot d'or avec Privilege du Roy*;
below margin: *585*

Museum Purchase
990.103.3

Neufforge's *Recueil élémentaire* was published from 1757 to 1768 in one hundred fascicles of six sheets each, with a supplement of three hundred sheets finished in 1780. It is a complete manual for architecture, beginning with the classical orders and going on to show details of the layout and construction of buildings, including churches, townhouses, and palaces. Furniture is treated literally as a sub-category of the architect's art.

Although only Cahier 98, *Meubles de toutes especes à l'usage des appartements*, deals directly with furniture, Neufforge's furniture designs are quite remarkable. Printed in 1768, they have little in common with the delicate forms of the transitional Neoclassicism fashionable during the period. His solid, heavy constructions have been compared both to the taste of the 17th century and to the rigidity of Empire furniture.[1] In many ways, his furniture is a very restrained version of Piranesi's rather bizarre designs. Like Piranesi, Neufforge shows great inventiveness in decorative motifs. The baluster legs of the *Table de Cabinet* in the second row from the top are interpreted as torches, with flames used to support the table. The Egyptian headdresses on the terms used in the *Bureau de Cabinet* anticipate by one year the publication by Piranesi of the *Diversi maniere* (see No. 21) with its enthusiastic use of Egyptian motifs.

NOTE
1. Salverte 1930:29–30.

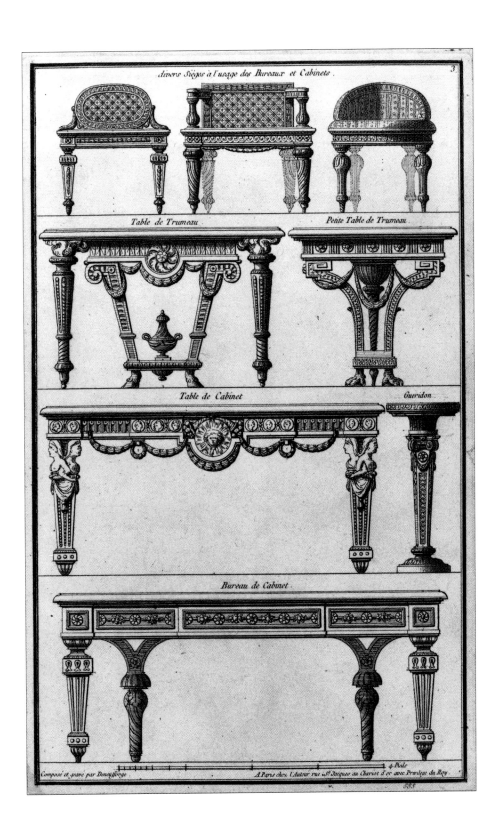

21. Giovanni Battista Piranesi, Italian (1720–1778)

Design for a Mantelpiece, from *Diversi maniere d'adornare i cammini ed ogni altra parte degli edifizi,* 1769

Engraving and etching
251 × 386 (plate)
Inscribed below left: *Cavaliere Piranesi inv. ed incise*
Literature: Foçillon 1918:910

Museum Purchase: The Helen Margaret Langstaff Bequest
986.269.2

The *Diversi maniere* is a collection of designs for chimneypieces and other furniture, including clocks, tables, vases, and even sedan chairs, many of which had been executed during the 1760s.[1] As with several of Piranesi's other projects, the plates were probably issued separately in the years preceding the publication. The collection is remarkable for its inclusion of designs incorporating Egyptian motifs. Although not the first to utilize Egyptian motifs as ornament, he did play a major role in popularizing the fashion.[2] In this design, the four Egyptian "caryatids" in profile at the sides of the chimneypiece are combined with more usual Roman objects. His designs are especially notable for their adaptation of the realistic mode of both Roman and Egyptian ornament. The fire dogs made of satyr figures, holding foliate swags and portrait medallions in this design, are a good example. Each design in the set is a compendium of motifs, often uniting Egyptian, Greek, and Roman elements into a new style of the designer's own invention.

As Neoclassicism began to sweep Europe during the 1750s, Piranesi played an important role in the development of the theory, or ideology, behind the revival of ancient forms. He became a great advocate of the superiority of Roman and, later, Egyptian art over the Greek art praised by Winckelmann. His massive, rich ornament, encrusting objects in ancient motifs, was an attempt to create a modern style of decoration based on the vocabulary of the ancients. His style was out of step with general 18th-century taste; the real influence of these works on practising designers came in the very late 18th and early 19th centuries when Empire and Regency styles took up the predilection for massive forms, rich decoration, and naturalistic detail.

NOTES
1. For a general discussion, see Wilton-Ely 1978:102–109.
2. Wilton-Ely 1978:107–108; Gonzalez-Palacios 1981:60.

54

22. Nicolas Ransonette, French
(1745–1810)

*View of Porcelain Painters' and
Modellers' Workshop,* Plate VIII from
Nicolas Christian de Thy, Comte de
Milly, *L'art de la porcelaine (Paris.
Académie des Sciences. Description des
arts et métiers),* Paris, 1772

Etching
317 × 392 (plate)
Inscribed above centre: *L'Art de la Porcelaine;*
below left: *Dessiner et Graver par N.
Ransonette* [with various figures identified in
image]

Museum Purchase: Gift of the ROM
Reproductions Committee
992.66.5.3

Ransonette's view of a porcelain workshop is the last of the illustrations for the Comte de Milly's groundbreaking work. The first book to accurately and fully describe the manufacture of porcelain, it not only provides valuable technical information, but confirms our understanding of the importance of porcelain in 18th-century society. For example, unlike the other contributions to this series of books on crafts, Milly's book is dedicated to the king. While a number of the contributions to the series are by one author, de Gersault, the books on embroidery and porcelain are written by experts, Saint-Aubin and Milly respectively.

Milly's text describes the view:

> Plate VIII represents the studio where are executed the work of the
> Painters, the Sculptors and the Modellers.
> Figure 1 represents the Furnace and the Muffle where the colours are
> fired onto the porcelain.
> Figure 2 is the workshop of the Sculptors.
> Figure 3 represents a worker grinding colours and another one who
> sifts them.
> Figure 4 is the work of the painters: one sees three artists occupied
> with painting three different porcelain vases.

Since Milly had previously described the sculptors as the makers of models from which are made the porcelain moulds, it would seem that it is they who are shown here, not the repairers who assembled and perfected the finished pieces, and who might logically have been shown with the painters.

The view of the workshop gives us visual evidence of the social status associated with porcelain, since the shop is located not in a cramped garret or dark factory but in an extremely grand room. Its high ceilings, large windows, and lavish carved woodwork can locate it only in a royal palace—the location of many porcelain factories, including the one at Ludwigsburg with which Milly was most familiar.

Social hierarchy among the workers is quite apparent from their varied costume. The simple labourers can be easily differentiated from the painters and sculptors with their jackets, their waistcoats, their lace cuffs, and their three-cornered hats worn over carefully coiffed hair. Sculptors were the most valued workers in porcelain factories; the artistic director of the factory was usually the chief sculptor or modeller, as is confirmed here by the details of dress.

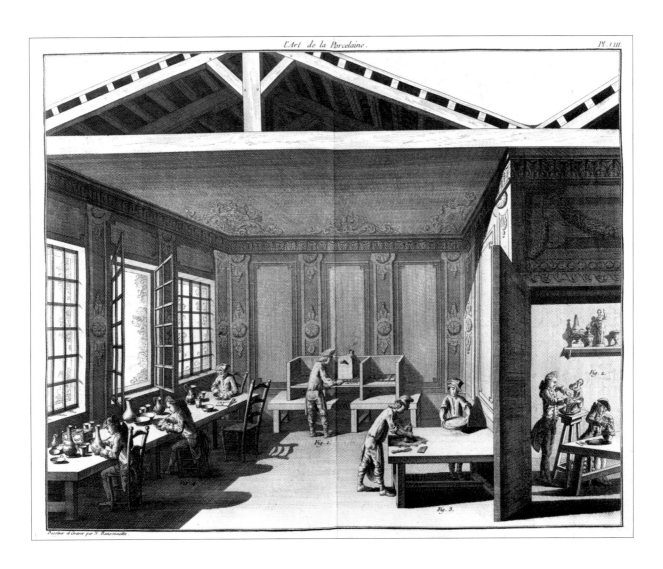

Dessiné et Gravé par N. Ransonnette.

Nicolas Ransonette 57

23. Karl Friedrich Schinkel, German
(1781–1841)
Etched by Friedrich Wilhelm
Schechten, German (1796–1879)

Design for a Sofa and a Chair, 1836,
Sheet 14 from Section 11 of *Vorbilder
für Fabrikanten und Handwerker*, Berlin,
1821–1837

Etching and aquatint
489 × 316 (plate)
Inscribed below: *erfunden u. gez. v. Schinkel
gest. v. Schwechten. gedr. v. Prêtre.*

Museum Purchase: The Helen Margaret
Langstaff Bequest
987.34.10.8

Although pattern books had been issued since the late 15th century with the idea of being useful to artists or improving the general quality of work, the governmental involvement in this project brought such goals to a new level. With public discussion in the 1990s of the necessity of education to international industrial competitiveness, it is important to note that this book was a direct result of 19th-century Prussian industrial policy. Since about 1810, the Prussian government had realized that, in order to find a secure market for their products, it was necessary to promote a high level of excellence in design and manufacturing trades. In 1819, the government created a "Technical Deputation for Trades," of which the architect Schinkel was a member.

In 1821, Schinkel was commissioned to oversee the production of a book to provide models of excellent design.[1] The plates would print only a limited number of impressions, so it was decided that the book would not be sold commercially, but would be given as a distinction to libraries and public agencies, schools teaching drawing, and artists and craftsmen who sought to provide good examples. The book was published in fascicles from 1821 until 1837 when a complete edition with 150 plates was issued. In 1859, galvanic copies of the printing plates were made and a reprint was issued. In 1863, a text volume was published.

The book contained three classes of designs: drawings of antique architecture; designs by Schinkel and others for furniture, glass, metalwork, etc.; and textile designs. There are about forty plates after designs by Schinkel, usually reproducing work he had already made. All of the works, even those for progressive materials such as cast iron or pressed glass, are examples of Schinkel's massive rectilinear interpretation of classicism, most based quite closely on ancient or Renaissance designs. The furniture designs included in the book record commissions for various palaces belonging to Prussian royalty.

The suite of furniture shown here was designed in 1831 for the Berlin palace of Prince Albrecht. The prints are especially interesting as documents of Schinkel's designs for upholstery textiles, since none of his furniture survives with its covering intact. Destroyed in World War II, the chairs and sofa were upholstered in elaborate cloth made expressly for them, with round panels showing classical figures. In the frame, and especially in the design of the fabric and the use of round bolsters, Schinkel reveals his debt to the furniture designs of two of the founders of this heavy classical style, Percier and Fontaine.[2]

NOTES
1. The best discussion of the *Vorbilder* is Berlin 1981; the sheet here is no. 322a.
2. Hempel 1989:144–148.

24. Unknown Artist, American

Two Japonesque Border Designs, 1877

Five-colour lithographs

a. 229 × 165

Inscribed: *Copyrighted by J.H. Bufford's Sons Boston, Mass.*

Gift of Dr. Peter Kaellgren
989.101.3

b. 227 × 164

Inscribed: *Copyrighted 1877. By J.H. Bufford's Sons, Boston.*

Gift of Dr. Peter Kaellgren
989.101.4

Probably intended as blanks for handwritten menus, these two sheets with Japanese-style border designs are from a salesman's sample book. The motifs are inspired by Japanese woodcuts, including titles, censor's marks, and publishers' addresses. The "title" at the left side of No. 24a is partly copied from a set of Views of Edo, although the image has nothing to do with it. This bowdlerized version of Japanese art is indicative of the rage for *Japonisme* in the United States, which began in the 1870s and peaked in the 1890s with a fad for various types of "Japanese" merchandise. As in France during the 1860s and 1870s, there were several layers of fascination with Japan. While the influence of Japanese art was part of an important shift to new subject matter and style in Western art, both aesthetes and middle-class consumers in Europe and the United States played at being Japanese in a grown-up version of make-believe.

Along with a small market for high-quality Japanese art, there was a huge market in the United States for fans, umbrellas, and

a

other novelty items.[1] The first surge of popularity followed the success of the Japanese Bazaar at the 1876 International Centennial Exhibition in Philadelphia, the year before these designs were copyrighted. After 1885 there was an even stronger rage for Japanese objects, with the appearance of Gilbert and Sullivan's *The Mikado*. While these menu cards are merely attempting to be in the Japanese style, rather than imitating actual Japanese objects, there was a considerable business in manufacturing "Japanese" goods in the United States and elsewhere in the West:

NOTES
1. Brandimarte 1991.
2. Alanson Goodwin, "The Japanese Novelty Store," Munsey's VI, 1 (October 1891):55; cited in Brandimarte 1991:1.

> Cranes, fishes and dragons,
> and Cloisonné flagons,
> No man can say what they're for;
> But—down to the stork—
> They're all made in New York
> For the Japanese Novelty Store.[2]

b

25. Albert Robida, French (1848–1926)

Lettres Japonaises, from *La Caricature*,
30 July 1881

Relief print, with stencilled colouring
372 × 270 (sheet)
[Extensive text]

Museum Purchase: The Helen Margaret
Langstaff Bequest
987.34.1.3

The fashion for *Japonisme* in France began in earnest in the 1860s, with impact on all of the visual arts. Throughout the 1870s and 1880s much of its application to decorative arts remained a rather mindless adaptation of motifs and patterns taken from Japanese art. It also became a fad for all types of costume and festivities to be given an air of modishness by a superficial overlay of Japanese style.

Robida reflects the fad in this issue of *La Caricature*. The brief text is a satire of contemporary Parisian institutions and life as seen through the eyes of an outsider, in this case a Japanese man visiting Paris. He writes home, describing Parisian fashion and behaviour, his visit to a night club and the opera, and so on. Apart from the current fashion for things Japanese, his being Japanese doesn't really have much significance, although the traveller's account of an exotic locale is a reflection of the popularity of this genre in Europe.

Nonetheless, Robida has redesigned the cover of *La Caricature* to imitate the layout of a Japanese print, aping Japanese calligraphy and parodying a Japanese print in his view of a Parisian bridge. Even the chaotic arrangement of the female figures may be a reference to the new freedom of composition introduced into French art by the influence of Japanese art:

> Japonisme! Attraction of the age, disordinate rage, which has invaded everything, taken command of everything, disorganized everything in our art, our customs, our taste, even our reason.[1]

NOTE
1. Cleveland 1975:147, citing Victor de Luynes in an 1882 report about ceramics at the 1878 World's Fair.

26. George Auriol, French
(1863–1938)

Program for the Théâtre Libre, 1889

Six-colour lithograph
215 × 310
Inscribed above left: *THÉÂTRE LIBRE;*
below left: *George Auriol;* verso: [extensive text]
Literature: Fields 1985, no. 33

Museum Purchase
992.94.1

Auriol arrived in Paris in 1882 to be a writer, and quickly fell in with the artists and writers involved in the avant-garde theatre, especially the Chat Noir.[1] From 1883 to 1893 he was listed as *Secrétaire de la Direction* of the *Chat Noir* journal. He increasingly turned toward the visual arts, designing twelve covers for programs for the Chat Noir theatre. A number of the small experimental theatre groups in Paris used the services of equally experimental artists to design such programs, often complementing the play presented with a lithograph of high calibre.[2] This program has the Auriol image on one side of the sheet and the text of the program on the other. Although first used for a performance on 21 March 1890, this exemplar has the program text for 2 May on the verso. The plays performed were *Jacques Bouchard* by Pierre Wolf, *Une nouvelle école* by Louis Mullem, and *La tante Léontine* by M. Boniface and E. Bodin. There is no obvious connection between the image and the plays.

Auriol began printmaking as a follower and colleague of Henri Rivière, the leader of the woodcut revival and a fanatical *Japoniste*. Under his influence, Auriol developed a style of decoration completely imbued with the aesthetic of *Japonisme*. The image shown

here, his only program for André Antoine's Théâtre Libre, is based on the motifs and style of traditional Japanese painting. The free asymmetry of floral and other natural motifs, combined with a sophisticated awareness of the relation of figure to ground, inspired artists and decorators in many media to a complete renewal of Western ornament.

This piece is from the beginning of Auriol's artistic development, but the Japanese influence on his style was of fundamental importance. He was active as a designer of covers for sheet music and books, and of typefaces, through the early 20th century. Floral designs with a strong planar element were a hallmark of his work. He also developed a very striking typeface based upon the forms of letters drawn with brush and ink.[3] An incipient version of this type is used here for the words "Théâtre Libre," although here it seems to be literally brushwork.

NOTES
1. See Fields 1985.
2. Pully 1991; the program shown here is Pully, no. 4, colour ill. p. 16.
3. Fields 1985:91–95.

Along with his partner, André Mare (1887–1932), Süe was one of the prime exponents of the lavish romantic aspect of French Art Déco. Mare arrived in Paris in 1903 to train as a painter, and quickly became part of an artistic circle that included Léger, Villon, Duchamp-Villon, Rouault, and many others associated with the Salon des Indépendents.[1] He turned increasingly away from painting toward the decorative arts, designing his first furnishings in 1910 for a display at the Salon d'Automne in 1910, and for the same venue in 1912 he designed the *Maison Cubiste.*

Louis Süe began work as a designer at approximately the same time.[2] In 1912 he founded the Atelier Français, inspired by developments in Munich and Vienna, but intended to promote a new French style of decoration. His style was to be based on nature: "baskets and garlands of fruits and flowers would contribute the

27. Louis Süe, French (1875–1968)
Etched by Jacques Villon, French (1875–1963)

Détail de la Niche, Salon de M. Ch. Stern, from Louis Süe and André Mare, *Architectures,* Paris, 1921

Etching
418 × 282
Inscribed below: *Echelle de 0,10; Louis Süe. inv. Jacques Villon. sc.*
Literature: Ginestet and Pouillon 1979, no. E613

Museum Purchase
992.75.1

DÉTAILS DE LA NICHE

Echelle de o.10 Louis Süe. inv Jacques Villon sc.

mark of the new style."[3] When Süe and Mare joined forces in 1919 to found the Compagnie des Arts Français, forms from nature would remain one of the hallmarks of their decorative vocabulary.

The connection between avant-garde artists and decorative arts in Paris during the 1910s and 1920s was quite close.[4] Mare's own work as a painter brought him into contact with many artists. It is therefore not surprising that the pair would have recruited Villon to provide the very stylish etchings for their publication. Additionally, Laurencin, Segonzac, Laboreur, and Villon provided their own original prints, not based on the work of Süe and Mare. The publication takes on the quality of a collaborative artists' book, as much as documentation of the firm's projects. Prefaced by a text by Paul Valéry, the book documents an aesthetic approach to decoration, a particularly conservative interpretation of modernism. The projects presented are typical of the firm's output, in their use of restrained, stylized natural forms as decorative elements on conservative but lavish architecture and furnishings. Throughout the *salon* for Charles Stern, in which the niche seen in this plate was one of a symmetrical pair, the walls were painted a dark green. Carved wooden architectural details, such as the capitals and the shell moulding in the top of the niche, were gilded. The walls of the niche were mirrored glass, and the fruit seen in the node of the shell is a crystal light fixture.

The work of Süe and Mare was well received, and they were among the outstanding designers represented at the 1925 Exposition International des Arts Décoratifs. They received numerous commissions from the French government, as well as for projects such as the design of the decoration for the ocean liners the *Paris* and the *Ile-de-France.* Nonetheless, the Compagnie des Arts Français was not a financial success. In 1928 Süe and Mare were forced to sell the firm to the Galeries Lafayette, and the partnership was ended.

Although only five hundred copies of *Architectures* were printed, it apparently did not sell very well. After the sale of the firm, Süe and Mare's successors removed the most valuable prints for sale as single sheets.[5] This exemplar may come from that stock, for it is missing several of the more notable etchings, such as Villon's *Baudelaire (sans le socle),* which do not appear to have ever been bound in with these sheets.

NOTES
1. Strasbourg 1971:8–17.
2. George 1952:48–56.
3. Véra 1912:32.
4. Troy 1991.
5. Strasbourg 1971:17, citing unpublished memoirs of Mare's wife, Charlotte.

28. Dimitri Semionovitch Stelletski,
Russian, active in France (1875–1947)

Matinée au Profit des Artistes Russes Résidant en France, 1914–1917

Four-colour lithograph
1306 × 806
Inscribed below right: *D. STELLETSKI.;*
below left: *I LAPINA IMP.EDIT.PARIS*
[extensive text]
Literature: Frühe Plakat 1977, II, no. 802

Museum Purchase: Gift of Mrs. Richard Gilbert
990.243.4

NOTES
1. The most complete biography is in Schleswig 1991:182; the poster shown here, dated to "about 1919," is Schleswig, no. 332, colour ill. p. 70.
2. See Frühe Plakat 1977, no. 802, from the collection of the Kunstbibliothek, Berlin. The most complete catalogue of French posters, Frühe Plakat 1977 lists only this poster as printed by Lapin.

Stelletski is among the many Russian artists who emigrated to France in the 1910s.[1] He studied in St. Petersburg and then briefly in Paris before returning to St. Petersburg in 1904. During the following nine years he was active as an illustrator, stage designer, and painter. He made his name with works in the style and technique of traditional Russian art, with particular success in a 1909–1910 exhibition in St. Petersburg.

The traditional forms of Russian folk art became quite popular after 1906, when Sergei Diaghilev organized an exhibition of seven hundred works of Russian art at the Grand Palais in Paris. Russian artists gained special fame in stage design, largely through Diaghilev's various productions. Russian traditional art appeared in work by such designers as Leon Bakst, whose designs for costumes for *The Firebird* (1910) and *Boris Godunov* (1913) gave this style a prominent role in France as well as in Russia. It was into this Paris milieu that Stelletski arrived in 1914. He never met with great success there, remaining fairly obscure until his death in a Paris suburb in 1947.

This is the only poster Stelletski is known to have designed, and the printer, Lapin, is also virtually unknown.[2] Issued for a benefit for Russian artists in Paris, it has been variously dated to 1914 and 1919. Although they had been coming to Paris for many years, there was a large emigration of Russian artists after the Revolution in 1917. Since Rodin died in November of 1917, this event can only have occurred between Stelletski's arrival in Paris in 1914 and May 1917.

The design presents a compact group of figures dressed as boyars organized into a lobed arch form. The flat, angular forms are embellished by the colourful patterning of the costume typical of this nationalistic, romantic Russian folk style. The three foremost figures hold a scroll, a statue, and rolled paper, and would appear to represent artists. The lettering above and below is in a style recalling the forms of the Cyrillic alphabet, while the names of the participating celebrities are given in panels constructed of rather Eastern-looking ogival arches.

The folk style used here by Stelletski is comparable to the tendency in Russian decorative arts of the period. The revival of interest in traditional Russian forms extended to metalwork. Brightly coloured enamel work and traditional Russian forms of vessels, such as the *kovsh* and the *tcharka*, were a significant aspect of production before the Revolution for manufacturers such as Fabergé (see No. 53). The bright colours and simple forms of folk art continued to provide inspiration for one strand of art produced after the Revolution, although the subject matter was restricted to images of peasants.

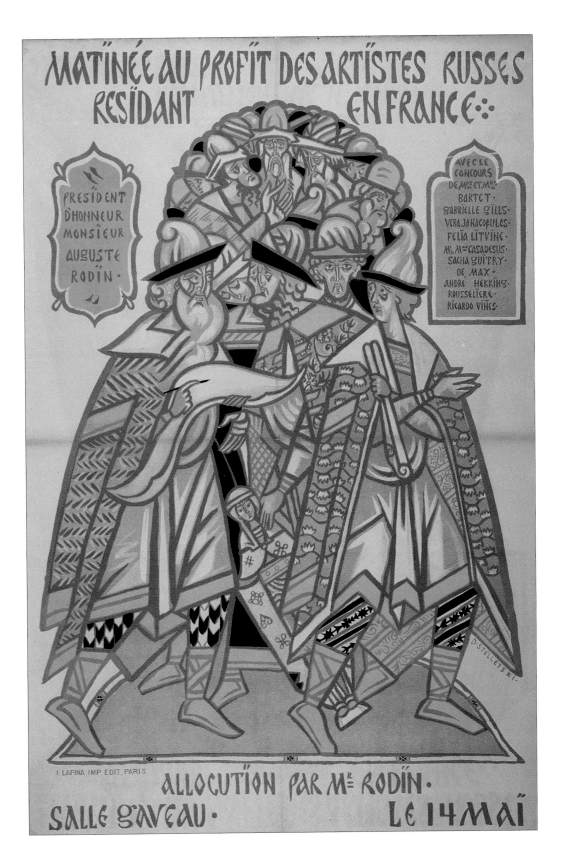

29. Moravek, Czech (active c. 1930)

Prague International Trade Fair, 1930

Four-colour lithograph
941 × 623
Inscribed above right: *MORAVEK;* below:
*FOIRE INTERNATIONALE DE PRAGUE
7–14 SEPTEMBRE 1930;* below right: *Unie
Praha*

Museum Purchase
992.76.1

This poster by a little-known artist reflects developments in avant-garde graphic design of the 1920s, albeit in a toned-down version. Designers sought to create a style of poster art appropriate to the new modern age, whether the works were meant to encourage consumerism in the bourgeois society of the industrialized machine age, or to celebrate the dawn of the socialist utopia.

The large colour blocks and sans-serif lettering are typical of Bauhaus graphics as well as of De Stijl design. While it is easy to imagine the influence of Bauhaus work on a Czech artist, elements of the poster seem more typical of Soviet poster design. Since these schools are all interrelated, it is probably not possible to precisely identify the influence on Moravek without biographical information. The schematically created skyscraper in this design bears an oversize sign, shown in foreshortened perspective but reading as a flat pictorial element. This presentation is reminiscent of Soviet designs such as El Lissitsky's poster for the Russian exhibition in Zürich of 1929 where the sign on an exhibition building is treated in the same way.[1] The use of lettering is also typical of Soviet architectural projects, using oversized lettering for graphic effect.[2]

A very similar perspective and similar subject matter (industrial buildings, streetcars, crowds on the street) were used a year later in 1931 by Alexander Deineka in his poster *Let us change Moscow into an exemplary socialist city of the proletariat!*[3] Like this piece, Deineka's poster is completely hand-drawn, unlike many of the experimental Soviet posters. The commonality between these posters is not coincidental, apart from whatever Moravek's political sympathies may have been (this poster is to advertise a trade fair). All of these works, as well as the slick, stylized images of speed and machines in the posters by Cassandre at the same time in France, share an optimism about the mechanized age. The bustling city in this poster is the home not of the downtrodden faceless crowd, but of the cheerful masses of workers.

NOTES
1. Frankfurt 1992, no. 414.
2. See several examples in Frankfurt 1992, no. 649 by Alexander and Victor Wesnin, and no. 658 by Ilya Golossow.
3. Frankfurt 1992, no. 660, with colour ill.

30. Robert Indiana, American
(b. 1928)

New York City Opera 25th Anniversary,
1968

Screenprint on silver-foil posterboard
889 × 635
Inscribed below left: *LIST ART POSTERS
1968 HKL LTD;* below right: *ROBERT INDI-
ANA 1968* [extensive text]

Gift in Memory of Joseph A. Melland
991.213.1

Indiana created a sensation in the mid 1960s with his clean, bold compositions, incorporating words and numbers in strong colours on simple geometrically shaped canvases. After he achieved notoriety with his many compositions based on the word "LOVE" (first exhibited in 1966), his work became an integral part of not only Pop Art, but of 1960s Pop Design. The use of reflective silver and brightly coloured inks in this work is reminiscent of similar prints by Andy Warhol from the same period—which also had great impact on Pop Design. It is indicative of the symbiosis of Pop Art with graphic and product design in general that Indiana's and Warhol's works were based on popular or vernacular imagery and themselves became vernacular images.[1] They transcended the context of art and became features in the landscape of design in the late 1960s. It would be difficult to identify any artists more closely related to the "period style" of the decorative arts of their era.

It has been noted by several writers that posters were an especially appropriate medium for Indiana, whose paintings were based on the elements of graphic design. Indeed, the posters have been praised as being among his most interesting work:

> The recognizable Indiana style is peculiarly adapted to meet those requirements [command the eye and convey information] and still offer a dazzling variety of solutions, which do not differ visually from his more subjective "sign paintings."[2]

The New York City Opera poster was created as part of a set of posters commissioned by List Art Posters of New York in 1968. It was included in a portfolio of posters for Lincoln Center along with works by Dine, Anuskiewicz, Laing, Nesbitt, Segal, and Youngermann. A signed edition of 125 was issued, as well as an unlimited edition screened onto silver foil.[3]

NOTES
1. See Mamiya 1992 for a recent discussion of the intersection of Pop Art and consumer culture.
2. Weinhardt 1990:92, with ill.
3. See Katz and Indiana 1971, nos. P14 and P15.

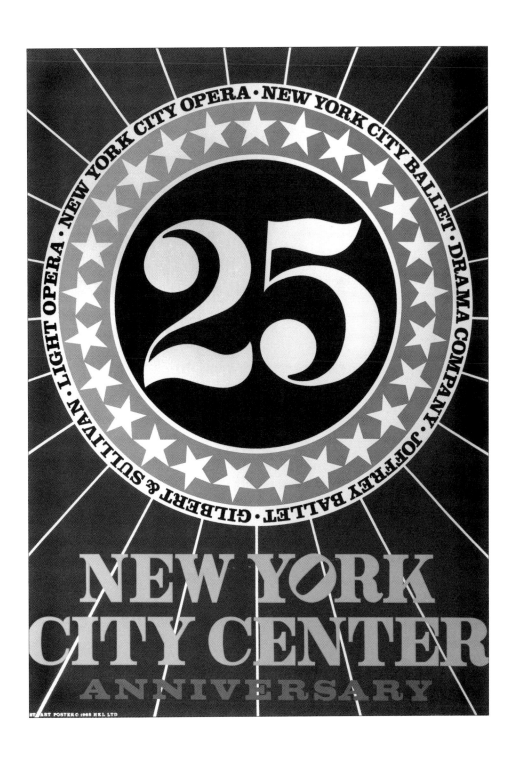

Moscoso, Wilson, and Mouse were three of the leaders in the creation of the Psychedelic poster in San Francisco in early 1966. The style was instrumental in beginning the poster revival that swept the Western world in the late 1960s. The sources of the graphic images and lettering exploited in these posters are as numerous as the influences upon the youth culture of which they were a part. American Indian culture, Art Nouveau, the Occult, and banal vernacular imagery all provided inspiration. Although the images are seldom satirical in an overt political sense, they do subvert the standard conventions of advertising graphics, and thus of the societal norms such conventions represent. One manifestation of this subversion is the complexity and illegibility of images and lettering. This was presumed to mimic the experience of a hallucinatory drug "trip." Another reading is possible: instead of reproducing the world as perceived by altered senses, the style causes viewers to alter their senses in order to decipher the poster.

Moscoso was the most sophisticated in experimental use of

31. Victor Moscoso, American (b. 1936)

Junior Wells, 1968

Offset lithograph
508 × 360
Inscribed below right: *1968 Moscoso* [extensive text]

Museum Purchase: Gift of Mrs. Sally Brenzel 988.201.15

32. Wes Wilson, American (b. 1937)

Joint Show, 1967

Offset lithograph
1105 × 635
Inscribed below: *1967 wes wilson-first edition-joint show-moore gallery-san francisco/lithographers neal, stratford & kerr*
Literature: Grushkin 1987, no. 2.349

Museum Purchase: Gift of Mrs. Sally Brenzel 988.201.5

33. Mouse Studios (Stanley Miller), American (b. 1940)

Skeleton and Roses, 1966

Offset lithograph
507 × 355
Inscribed below left: *MOUSE STUDIOS 66* [extensive text]
Literature: Grushkin 1987:97

Museum Purchase: Gift of Mrs. Sally Brenzel 989.78.10

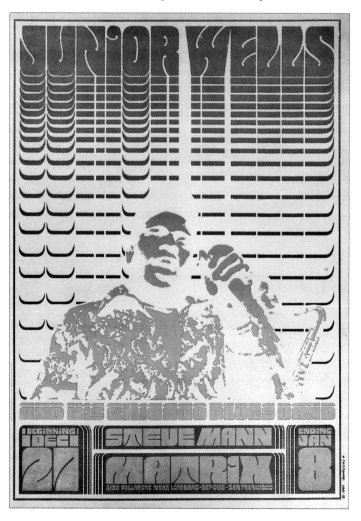

colour to this end. His *Junior Wells* presents an image that, while readable, appears to be a high-contrast photographic negative translated into the aggressive yet very fashionable colours of orange and chartreuse. When viewed under ultraviolet or simple blue light the effect is revealed; the poster changes from a negative image to a positive, very three-dimensional, image. "Altered perceptions" are necessary to understand the poster and, by extension, reality. This requirement of a multi-media environment for the poster and the incorporation of a temporal element into the work are related to the flowering of the light show as an art form as well as other developments in art of the period, such as "happenings."

Wilson was the leader in the development of the wild, hand-drawn typefaces that became identified with Psychedelic style. His work in early 1966 featured simple spatial effects created with flowing distorted letters. By the time of *Joint Show* in July of 1967, he had refined this effect, here creating a nude girl with a beach ball out of the names of the participating artists and other pieces of information.

No. 32

Only with considerable effort is the text intelligible—a deliberate flouting of the principles of "good design." Considering the use of nude female figures in several of Wilson's other posters, it is difficult to decide whether this use of a stereotypical "California" image is ironic. Like Moscoso, Wilson had a tendency to use the colours orange, chartreuse, and turquoise, which were quite fashionable in many fields of design in the late 1960s.

Stanley Miller, better known as "Mouse," created an image of remarkable longevity with *Skeleton and Roses*.[1] Although it had been used on a previous poster, this choice of the skeleton as the motif for the Grateful Dead proved fateful. Mouse's hand-drawn image, based on an illustration by E. J. Sullivan for the *Rubaiyat*,[2] has overtones of the exotic, the occult, and the forbidden, which were typical of one aspect of Psychedelic style. Due to its intimate connection with the Grateful Dead and their status as a cult band, the image has remained current for twenty-five years. In the intervening years, it has helped to popularize the style of illustration especially associated with Heavy Metal music.

NOTES
1. Commissioned by the concert production company Family Dog for the Avalon Ballroom, Family Dog Series, no. 26.
2. San Francisco 1976:9 and no. 61.

No. 33

34. Christof Rädle, German, dates unavailable

Cultur Bag, 1981

Offset lithograph on polyethylene bag
445 × 370
Inscribed centre: *Cultur;* verso:
[extensive text]

Anonymous Gift
989.54.1

Rädle's polyethylene bag was commissioned in 1981 by Wohltat's Buchläden, a chain of discount bookstores in West Germany. The opposite side features the name of the store and the addresses of its branches. The design utilizes an economical combination of the white plastic as a reverse in the green colour field to present the word *Cultur.* The elaborate script with the exaggerated serif on the "C" imitates the trademark symbol of Coca-Cola, the most recognizable logo in the world.[1] Another aspect of the Coca-Cola corporate identity, "the wave" or tapered white band in their packaging and signage, is evoked by the contour of the upper edge of the green field. Originally printed in red, the colour was changed for copyright reasons. Green was the "house colour" of the company and offered itself as an alternative.[2]

The reversal of the standard red used as a background colour by Coca-Cola to its complementary green may also be read as an indication of an ironic stance toward the symbol, like the reversal of colours in Jasper Johns' 1967–1968 lithograph, *Flags,* later used as a poster for the 1970 Moratorium against the Vietnam War.[3] Rädle's design was also available as a small sticker for customers in the

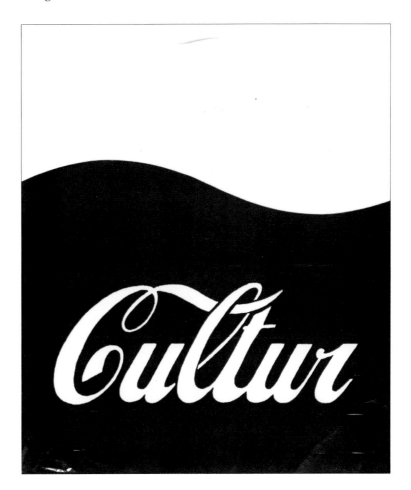

stores. The sticker made the Coca-Cola association more obvious by directly quoting the logo, in white and red with the entire "wave" repeated.

Rädle altered the spelling of the German word, *Kultur,* to *Cultur.* This retains the identifiability of the logo and alludes to the Americanization of German culture, a phenomenon for which multi-national American-based corporations are often seen as culpable. Coca-Cola itself is perceived as the quintessential American product, both within American culture, as expressed for example by Andy Warhol,[4] and by the rest of the world. In Germany, the consumption of carbonated beverages is considered to be an American habit and, in many circles, an undesirable one.

The design comments as well on the mass-marketing of culture itself. The very bookstores for which the bag was produced engage in the aggressive discount sale of books, in opposition to small bookstores where the act of purchasing a book is more an intellectual exercise than a monetary transaction. The idea—culture as a commodity which can be traded and packed in a plastic bag like clothing or groceries—is evoked by the rather penetrating satire of the merchant's own publicity material. Conversely, the design attests to the power of graphic design and its ability to create an identity for a product.

NOTES
1. Aldersey-Williams 1992:8.
2. Correspondence with the designer, 7 July 1992.
3. New York 1988:69, no. 119.
4. Warhol 1975:100–101.

These two photocopied handbills are exemplary of street-level design, typical of such advertisements which have proliferated since the late 1960s. In this instance, the style reflects the Psychedelic Revival, especially popular around 1988 in London. Superficial elements of Psychedelic or 1960s graphics are freely borrowed. The lettering in No. 35a is taken directly from several of Wes Wilson's later works. The spiral form in No. 35b, an advertisement for a boutique, is obviously taken from Op Art, itself a source for the Psychedelic designers. Both are meant to elicit the look of the 1960s, revived in conjunction with Acid House style. Kensington Market, where the handbills were acquired, was a centre for this fashion.

The works show the power of printing technology to form a style. The designers have both carefully chosen quotations from 1960s graphics that would work in black and white. It is interesting to note the intrusion of later style into this revival. The cut-and-paste effect of the letters in the *Acid Eye* design is based on similar handbills of the 1970s, which developed this lettering effect specifically in response to the limitations of xerography. The colour of the *New Apes* handbill is completely alien to the 1960s, but is instead dictated by the range of colour in commercially available photocopying paper.

35. Unknown Artist, British

Two Psychedelic Revival Handbills, 1988

Photocopies

a. *The New Apes*

183 × 136
[Extensive text]
Anonymous Gift
989.52.1

b. *Acid Eye*

210 × 155
Inscribed below right: *49, Kensington High St. London*

Anonymous Gift
989.52.2

a

b

By subject matter and its grand Baroque style, this design by Sir James Thornhill for a ceiling painting at Easton Neston indicates the aspirations governing the creation of a great English country house. In the late 17th and early 18th centuries, one way to assert social prestige was to enhance one's family seat by commissioning large decorative paintings from stylish artists such as Verrio or Laguerre. In keeping with his rising social position, Sir William Fermor began rebuilding and expanding his family estate in the 1680s with at least the counsel, if not the designs, of Sir Christopher Wren. After Fermor's marriage in 1692 to Sophia, daughter of the 1st Duke of Leeds, followed in the same year by his elevation to the barony of Lempster, he decided to modernize the building radically.[1] Nicholas Hawksmoor, perhaps taking over from Wren, designed the new central block of the house, which was largely completed by 1702. Between 1702 and 1713, Thornhill painted a set of grisaille panels of the life of King Cyrus for the staircase, and designed a painting for the ceiling of the Great Hall, to the right of the entrance hall. The *terminus ante quem* of 1713 is based on Colin Campbell's statement in 1713 that the house was finished.[2]

Our drawing has been connected with the design for the ceiling of the Great Hall by Brian Tupper, based on its similarity to a drawing in the Thornhill sketchbook in the British Museum. That drawing (fol. 56r) is inscribed in ink, "To Lord Lempster at Easton–Hall Ceiling." The drawing is measured, giving us dimensions of the painted area as about 10.7 m by 8.4 m (35 feet by 27.5 feet); this would have fit into the central section of the Great Hall, which was about 9 m (nearly 30 feet) wide and approximately square.[3] The

36. Sir James Thornhill, English (1675–1734)

Design for the Ceiling of the Great Hall, Easton Neston, with "Queen Anne as Britannia Promoting the Arts," 1702–1713

Pen and brown ink with brown wash, over black chalk on laid paper
262 × 418

Museum Purchase: Gift of Mrs. Mona Campbell
991.151.1

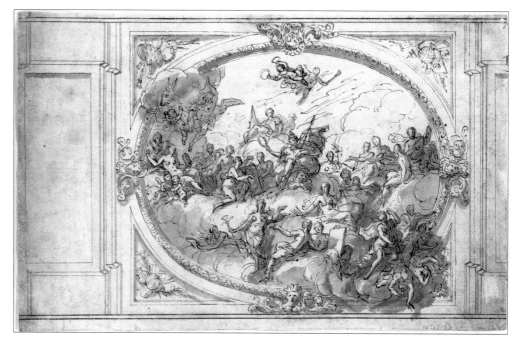

figural composition of the British Museum drawing is difficult to compare to the example here, because Thornhill used extraordinary shorthand draftsmanship in his sketches, but it is plausible that the ROM drawing is a more finished version of the design. The architectural details at either side of the composition are the same as in our drawing, as is the relation of the architecture to the oval panel.[4] Although the Great Hall of Easton Neston was completely altered in the 19th century, these details seem to match those recorded in photographs.[5] It is possible that the painting was destroyed in the course of the 19th-century alterations, but it is more likely that the Thornhill painting was never executed. In his very detailed description of the house in 1758, George Vertue describes the Thornhill paintings in the stairway, but makes no mention of any others. It is hard to imagine that he could have omitted any mention of such a grand ceiling.[6]

Tupper has proposed that the subject of the painting is "Queen Anne as Britannia Promoting the Arts," and this seems a logical speculation.[7] The central figure is indeed similar to the other depictions of Britannia, who is identified with Queen Anne in a drawing for the ceiling of the Upper Hall in the Hospital at Greenwich.[8] Interpreting many of the figures is difficult because Thornhill's allegories tend to be very complicated and idiosyncratic. The scheme for his decoration of the Lower Hall at Greenwich was so incomprehensible to viewers at the time that he finally published an explanation of it in 1730.[9] The ROM drawing clearly shows Britannia accompanied by figures representing Architecture, Music, Painting, and Literature (perhaps Poetry). Some of the figures are difficult to interpret, however, due in part to Thornhill's abbreviated draftsmanship. The exact identification of the group is not clear. It may include the Muses as well as general allegorical figures of the arts. To the lower right, at least two figures are being cast out of the celestial space, and probably represent Envy, who is frequently shown being expelled from the company of the Arts. The ass's head at the upper left is more of a puzzle, appearing as it does in a cloud. Could this represent Theatre with a reference to Bottom from *A Midsummer Night's Dream?*

Thornhill was the great exponent of the late stage of Baroque Classicism in England. Most of his painted work was for architectural decoration, primarily allegorical and mythological subjects framed in heavy illusionistic architectural elements. He received the two great English commissions of his age for such work—the painted decoration for the Hospital at Greenwich and for the Dome of St. Paul's Cathedral. This grand style of decorative painting was most appropriate for large representative spaces. Even in his work for private residences, Thornhill was usually engaged to do the stairwells and the great halls of the houses, rather than smaller rooms.[10]

NOTES
1. Lees-Milne 1970, 138-147.
2. Cited in Downes 1959:62, n. 37.
3. Downes 1959:61.
4. Fol. 55v of the sketchbooks contains measured drawings of the panels for the staircase as well as two rectangles, measured as 6.7 m by 3.3 m (22 feet by 11 feet), labelled "at each end of the Hall." The top rectangle is empty and the one below has an undecipherable design.
5. Downes 1959, ill. 7.
6. Vertue 1758:53–56.
7. Croft-Murray 1962–1970, who knew only the drawing in the British Museum sketchbooks, identifies it simply as *An Assembly of Gods* (268).
8. Mayhew 1967, no. 8, with ill.
9. Mayhew 1967:6.
10. For Thornhill's biography, see Croft-Murray 1962–1970, I:69–78, 265–274; also Mayhew 1967:5–10.

The drawing shows an extreme version of English chinoiserie design for woodcarving. The dramatic size and angularity of the hoho bird, the planarity and openness of the frame of the overmantel mirror, and the particularly prominent use of the "stalactite" or "icicle" motif are all driven to their ultimate stylization. This is placed atop an overdecorated but otherwise standard mantelpiece, which is rather jarring in conjunction with the mirror. The design can be roughly dated from its similarity to chimneypiece designs by known English designers. It shares some common elements with three designs for mantelpieces added to Chippendale's *Director* for the third edition, published in 1762.[1] The loosely spiralling vine on

37. Unknown Artist, English

Design for a Chimneypiece with Mirror, c. 1765

Pen and brown ink with grey wash on laid paper
Inscribed above right: *£-d-*; below centre: *3.8/3.6* [with scale at right]
293 × 203

Museum Purchase: Gift of
Mrs. Mona Campbell
987.53.2

the sides, the stalactites used as ornament, and the two slicing angled forms of the upper left and right which seem to derive from capitals drawn in perspective, are all contained in essence in a design like plate CLXXXIV of the *Director*. These designs, like many chimneypiece designs of the period, also show the odd discontinuity in design between the lower rectangular mantelpiece and the mirror used as an overmantel.

Very close in feeling to the overmantel in this drawing is a drawing for a mirror frame attributed to Chippendale in the Victoria and Albert Museum.[2] Dated to about 1760, that drawing shares many elements with this one. The spiralling vine, the stalactites, and even the odd vases holding flowers at the upper corners of the ROM drawing are seen in the Chippendale version. Apart from the mantelpiece designs, the remaining characteristics of the overmantel are easily found in several of Chippendale's designs in the *Director* for pier glass frames (plate CLXXIV) or designs for girandoles (plate CLXXVII). Still, the design does not simply copy one of Chippendale's plans, and the artist has used the motifs appropriately. Even though this might encourage speculation about the attribution of the drawing, the draftsmanship seems too weak and hesitant to be that of Chippendale himself, and another possible designer has not been identified.

NOTES
1. Chippendale 1754, plates CLXXIX, CLXXXII, and CLXXXIV.
2. Ward-Jackson 1958:46, no. 112, ill.

38. Unknown Artist, probably French

Design for an Ecclesiastical Candlestick,
1730s

Red chalk on oiled laid paper
1330 × 482
Literature: Fuhring 1989:372, no. 578

Museum Purchase: Gift of
Mrs. Mona Campbell
991.64.7

NOTES
1. Fuhring 1989:372, no. 578. Musée des Arts
Décoratifs inv. 45346. The drawing in Paris is
nearly identical in size (1350 × 480). It was
acquired in 1975 from the Odiot Collection,
as was this example. It shows a variation on
this design, in the same medium and with
the oiled paper laid down on an identical
backing, and shows the same light stains as
the backing of the ROM drawing.
2. Hernmarck 1977, I:336–337.
3. For example, a tureen from 1733–1734 in a
private collection (Frégnac 1966:121–122, ill.).

This drawing is a striking example of a full-scale rendering for an object. Especially for works in precious metal, a designer or dealer would provide the patron with a drawing of the work at full scale, instead of making a scaled drawing. This would enable even the least imaginative of customers to appreciate the size of the object. Such drawings may also have served as the working drawing for the silversmith, although this is not necessarily the case. For this drawing, the paper has been oiled to make it translucent, so that the drawing could be traced, and it is obvious that the very evenly drawn contour of the candlestick has been traced from another work. Perhaps a full-scale working drawing was retained in the shop while a tracing was sent to a potential patron—or vice versa. A similar drawing for a candlestick from the same workshop is in the Musée des Arts Décoratifs in Paris.[1]

This magnificent candlestick is identifiable as ecclesiastical by the seraphim on the base and by the size. Only ecclesiastical candlesticks would have been this large, usually made as one of at least one pair, *en suite* with an altar cross. Particularly fine examples have survived from the mid 18th century in Spain and Portugal.[2] This design is for a candlestick of conservative structure, with a triangular base supporting a baluster surmounted by an urn-form wax pan and baluster socket. The profile of the moulding between the base and the baluster, and the shape and decoration of the wax pan, are fairly staid and dry, but the triangular base and the baluster are freely designed in an accomplished Rococo manner.

The curving, plastic approach to the architectural forms of the volutes in the base and at the bottom of the baluster stem can be found in the work of numerous French designers of the 1730s, such as Juste Aurèle Meissonnier and Jacques de Lajoüe. The shell shape of the cartouche on the base and the irregularly shaped imbricated disks in the recessed panels of the stem are particularly reminiscent of motifs used by the Parisian silversmith Thomas Germain in his works of the 1730s.[3] Also comparable to Germain's work, with the exception of the volutes forming the base and those at the bottom of the baluster stem, is the use of Rococo motifs to decorate a structure otherwise formed of clearly profiled articulated elements. His great contemporary, Meissonnier, led the way to more extreme Rococo design in silver, where the entire structure of a piece is reshaped as one large organically integrated decorative element.

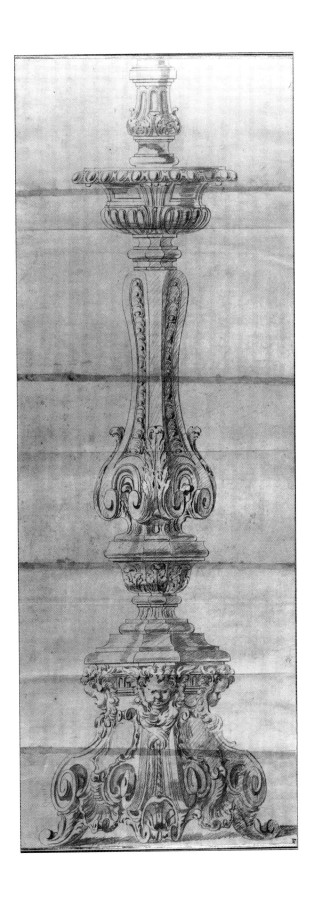

39. Attributed to Gabriel Huquier,
French (1695–1772)

Design for a Decorative Panel,
c. 1740

Graphite and black chalk on laid paper
143 × 243

Museum Purchase: Gift of
Mrs. Mona Campbell
989.62.1

This drawing shows a family of merpeople in an oval cartouche framed by foliate moulding. The cartouche moulding is in turn surrounded by grotesque ornament motifs, including baskets of flowers, bats' wings, floral garlands, stylized palmettes, interlacing knots, spear-like foliage, and a diapered pattern of lozenges with flowers at the intersections. All of the decorative elements in the border appear in various engravings after Antoine Watteau by Gabriel Huquier, used in the *Recueil Julienne*. It has been determined that those borders are largely the work of Huquier, based upon elements of Watteau's ornamental vocabulary.[1] Although most of the central subjects in Huquier's engravings after Watteau are freestanding within the field of the decorative grotesque, such oval cartouches do occur; for example, in a set of images with landscapes representing *The Four Seasons*, in the *Birth of Venus*, and in *Rain*.[2] However, among the prints after Watteau, there are no other compositions with large figure groups within cartouches.

Elaine Dee has suggested that there may be more than simple borrowing of motifs from the Huquier prints.[3] The drawing is quite freely and fluidly executed, in a style of draftsmanship not at all unlike the drawings usually attributed to Huquier, although this piece is not as grandly conceived as are, for example, the works in the Cooper-Hewitt collection.[4] The subject is much smaller and the ornament more densely organized. The ornament is not brought to the same finished state as in the Cooper-Hewitt drawings, which are the immediate preparatory drawings for engravings. Nonetheless, the abbreviation of the flowers in the garlands and baskets, and the other ornamental motifs, are quite similar to the Huquier drawings. It is difficult to identify comparative material for the central scene within his small oeuvre of drawings. An attribution to Huquier is not conclusive on this basis; however, if this is another draftsman creating a pastiche of Watteau/Huquier motifs, it is a very competent one.

NOTES
1. Eidelberg 1984.
2. Dacier and Vuaflart 1921–1929, nos. 140–143, 283–284.
3. Elaine Dee, verbal communication with the author.
4. Cooper-Hewitt Museum, Smithsonian Institution, New York, 1911-28-294, 1911-28-296–297; see also Eidelberg 1984.

40. Ange-Jacques Gabriel, French
(1698–1782)

*Elevation for a Wall in the Apartment of
the Dauphine at Versailles,* 1744

Pen and grey ink with grey, blue, green, and
red wash on laid paper, pricked for transfer
365 × 474
Literature: Fuhring 1989:214–215, no. 217

Museum Purchase: Gift of
Mrs. Mona Campbell
991.64.5

Gabriel replaced his father as *Premier Architecte du Roi* in 1742, and served in that capacity until his death. He was responsible for numerous alterations to Versailles, as well as other royal residences, and was the architect of the Petit Trianon and the Place de la Concorde. His first major task in interior design after the death of his father was the renovation of apartments in the *Aile du Midi* of Versailles for the Dauphin and Dauphine. The renovations were designed and carried out in 1744, before the marriage of the Dauphin to Maria-Thérèse-Raphaëlle of Spain on 23 February 1745.[1] Due to later remodelling, nothing survives of the rooms with the exception of one fireplace, now in the Trianon.[2]

The ROM drawing, first identified by Alfred Marie, can be associated with the apartment of the Dauphine by the incorporation of the arms of Castile, featuring a castle and her initials, MT, surmounted with a crown, in the panel at the left. The drawing divides the wall into four sections: a panel with carved wood decoration, the doorway and the rich frame of the overdoor painting, a mirror designed as a unit with its accompanying side table, and the frame for a piece of tapestry. The inclusion of the side table as a part of the design for the wall treatment demonstrates the continental conception of this type of table as a part of the interior architectural finishing, rather than as a movable piece of furniture. Because an appropriate place had to be provided for them in the room, side tables were designed by the architect and often made by the same craftsmen who provided the other *boiseries,* or wood panelling.

Four elevations of the walls of a room in the Dauphin's apartment are at the Musée Condé in Chantilly, signed by Gabriel and dated 1744.[3] All the drawings show *boiseries* in a fairly conservative style. The drawings in Chantilly are rather restrained in their use of ornament, with the carved decoration always contained within the rectangular panels. The ROM drawing, for a room that cannot be identified with precision, shows the wall more richly treated with sculptural decoration. Brackets are added at the cornice level and the heavily carved elements, such as the coat of arms over the looking glass, the frame for the overdoor painting, and the coat of arms at the top of the *boiserie* panel at the left, all break through the line of the cornice. However, Gabriel does not indulge in the asymmetry and rich sculptural effect that was high fashion in the early 1740s. His style is more linear and regular, dividing the elevations into rectangular units. He was restrained from bold experimentation by his own choice, by the need to harmonize with existing decoration in the surrounding rooms,[4] and by the conservative nature of royal taste.

The carved ornament is very similar to the *Cabinet* Gabriel designed for the royal princesses at Fontainebleau in 1745, and to the surviving work in the apartments of the Dauphin done in 1746,

where the mirror has many details in common with the one here. As in many design drawings, the designer depends greatly upon the skill and taste of the executing craftsman for the success of the details of the scheme. Gabriel worked repeatedly with the wood-carver, Jacques Verberckt (1704–1771), who required only general instructions as to what was to be created.

Tadgell points out that Gabriel's position as *Premier Architecte* was an extremely demanding administrative post. Gabriel himself did not execute all the drawings that emanated from his office. Tadgell divides the drawings into four groups, which could apply in general terms to any architect's drawings: sketches by Gabriel himself, project drawings by his assistants which he revises, presentation drawings for official approval, and measured working drawings.[5] Applying these criteria to the ROM drawing, it seems that this is a presentation drawing, since the careful finishing with wash would not be necessary for any other use. The drawing has been extensively pricked to aid in transferring the composition to another sheet.

NOTES
1. Although the construction is dated 1745–1746 (Baulez 1982:157), Tadgell 1978:97 states that the Dauphin moved into his portion on 9 December 1744. Also, Mesdames Henriette and Adélaîde were moved out of their apartments in 1744 to make way for the new space for the Dauphin and his bride.
2. Baulez 1982:157.
3. Marie 1984:548–549, ill. 206; also Baulez 1982:155–157.
4. Tadgell 1978:42.
5. Tadgell 1978:15.

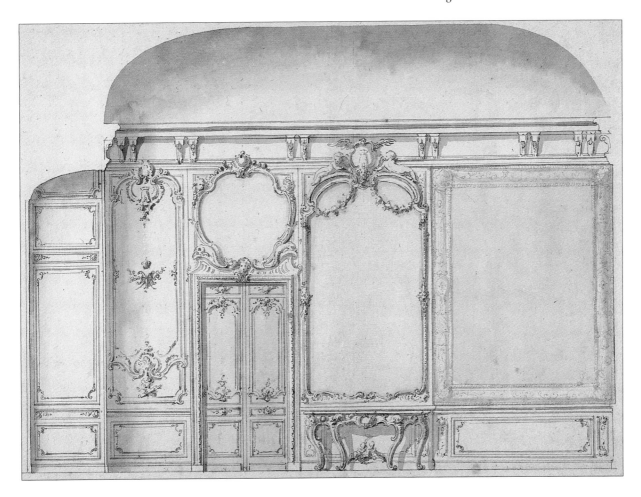

Weisweiler produced some of the most exquisite furniture of the
late 18th century, with a characteristic style featuring frequent use
of inlaid porcelain plaques. This drawing shows a drop-front *secré-
taire* with alternative designs for the legs and side columns. The
drawing is a nearly exact match for a *secrétaire* in the Palacio de
Oriente, Madrid, purchased in Paris between 1805 and 1807 by
Marie-Louise of Parma, Princess of the Asturias, later Queen of
Spain.[1] The existing piece uses the lower left and upper right alter-
natives for the designs of the legs and colonettes. The square panel
of the front has a simpler design with foliate decoration; the circular
composition in the centre and the smaller medallions around the
borders are porcelain plaques from the factory of Dihl et Guérhard.
The arrangement of the porcelain plaques is identical, although
they show different subjects from those in the drawing.

A *secrétaire* apparently in very similar style is listed in an inventory

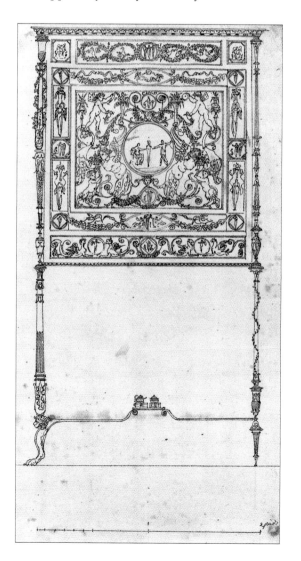

of Versailles from shortly after the Revolution,[2] so although it is conceivable that Weisweiler was still producing furniture in an outmoded style in 1805, what seems more likely is that the *secrétaire* was acquired as a used piece. The market for second-hand luxury furniture must still have been well supplied in 1805.[3]

If we assume that the drawing is specifically related to the piece now in Madrid, and it is as close as most furniture drawings get, it does point up that the use of such alternative drawings may be more complicated than one might think. It was not a simple question of choosing left or right. The mismatched colonettes, however, do tell us that this drawing was not a working drawing, which would probably need to be in more detail. Rather it is a drawing to be sent to a potential patron, including a scale for his or her information. According to the scale at the bottom of the drawing, the piece is 3.8 *pieds* tall and 2.1 *pieds* wide (1.23 m by .68 m),[4] typical measurements for a Weisweiler *secrétaire*.

The question of who designed furniture in the late 18th century is more problematic than it might seem. The furniture maker, or *ébéniste*, did not work directly for private clients, but was contracted by a dealer called a *marchand-mercier*. Weisweiler's very distinctive style of furniture is notably close to the style of Martin Carlin (about 1730–1785), who also used porcelain plaques, for example. Both men supplied works to Dominique Daguerre, a dealer, and it has been speculated that the style and the use of porcelain were at his instigation.[5] This is important to an understanding of the drawing because the dealer may well have provided the drawing to his client and then to Weisweiler. The difficulty of differentiating the designs for the two makers is evinced by the comparison of a drawing in the Metropolitan Museum with a Weisweiler *secrétaire* in the same museum.[6] Although the rectangular panel at the bottom edge is typical of Weisweiler, the continuous frieze of drapery or foliate swags is much more typical of work by Carlin.[7]

In any case, the style of the drawing provides no clue. Even among the drawings associated with surviving Weisweiler furniture, there are clearly different draftsmen at work. The drawing in Paris,[8] for a console table now in the British Royal Collection is competent, but is not by the same draftsman as the ROM drawing. A drawing that relates to several surviving *gueridons*[9] is quite crude in comparison to either the previous work or the ROM drawing. In short, apart from the common use of outline drawing in black pen, which is simply period style, there is little to indicate that any of the "Weisweiler" drawings are by the same hand. Weisweiler did not draw the design and may not have had more than a consultative role in its creation. While we do not want to reduce the craftsman to the level of a machine, we must remember that there were many participants in the creation of such a piece.

NOTES
1. Plinval de Guillebon 1972:143, ill. See also Lemonnier 1983:179, no. 67, for a *secrétaire* with a plaque of Sèvres porcelain.
2. Lemonnier 1983:65, colour ill.
3. One can only imagine what was still available, when the sale of furniture from Versailles had run from August 1793 until September 1795; see Verlet 1955:xx–xxi.
4. A *pied* equals 32.48 cm.
5. Pradère 1989:390.
6. New York 1992:197–198, no. 117, as Anonymous.
7. Pradère 1989:346, ills. 405, 407, 416, 419.
8. Musée des Arts Décoratifs, Paris, inv. CD 5082/6; Lemonnier 1983:75, ill.
9. Musée des Arts Décoratifs, Paris, inv. CD 5080; Lemonnier 1983:90, ill.

42. Attributed to Pierre Moreau,
French (d. 1762)

Design for a Snuff Box, c. 1760

Pen and black ink and watercolour on laid paper
95 × 116
Literature: Fuhring 1989:376–377, no. 586

Museum Purchase: Gift of
Mrs. Mona Campbell
991.64.2

Gold boxes are the very epitome of 18th-century decorative arts. Intimate objects made of valuable material enhanced by virtuoso workmanship, they were produced in a great variety of shapes and techniques. They became the standard luxury diplomatic gift. One's wealth and taste were easily judged by the quality of one's *tabatière*.[1] This drawing shows a gold snuff box with translucent enamels and relief decoration in the foliage on the top and side and in the trophy in the central panel of the side. The gold reliefs may well be intended for execution in coloured gold. The blue oval set in the top may indicate either a large precious stone or simply the opening where an enamelled scene or portrait of the patron's choosing could be inserted. As with many design drawings, it could have served as a drawing for presentation to a customer, or as a finished working drawing, or both.

Fuhring attributed this drawing to Moreau on the basis of its similarity to the large group of drawings under his name at the Musée des Arts Décoratifs in Paris.[2] Moreau is also known as the engraver of a set of printed designs for boxes, stick handles, and other small *bijouterie*.[3]

NOTES
1. Snowman 1966:53–54.
2. Snowman 1966:62–63, ills. 93–106.
3. Berlin 1939, no. 873. See also foreword to New York 1987, which discusses the whole complex of these types of drawings from mid-18th-century Paris.

43. Jean-Charles Delafosse, French
(1734–1789)

Design for a Clock, c. 1770

Pen and grey ink with grey wash over pencil
on laid paper
269 × 100
Inscribed below left: *JCD*
Literature: Fuhring 1989:327, no. 504

Museum Purchase: Gift of
Mrs. Mona Campbell
991.64.4

Delafosse was trained as a sculptor, taught drawing, and aspired to be an architect. He is identified with a version of Neoclassicism characterized by the use of massive solid forms, with richly plastic volutes and swags. The drawings associated with his name are of varying quality, but this design for the case of a clock is in unusually commanding style for Delafosse. Many of his more finished drawings are rather dry and precise, and the ornament in engravings after his designs often has a lifeless heaviness and pointless massivity. Seen in the freshness of the original inspiration, his interpretation of Neoclassicism takes on an almost Baroque quality of drama through the movement and life of these figures. This quality distinguishes many of his better drawings.[1]

Figures with arms thrust upward, especially pairs of female figures, were a common motif for Delafosse. A very similar pair of female figures appears in a design for a cassolette by François Boucher *fils* from the mid 1770s.[2]

NOTES
1. See Musée des Arts Décoratifs, Paris, CD 243, Design for a Brûle-Parfum; also, the two designs for urns in the Metropolitan Museum of Art (New York 1992, nos. 31, 32), where the similarity of the designs to the tradition of such designs for urns and vases is made clear.
2. Berlin 1939, no. 1267, fascicle 63, sheet 373.

The design shows two alternatives for a hardstone bowl in a gilt-bronze mount on an extended octagonal pedestal with foliate scrolls as feet. To the left is a view of the mount and pedestal in plan. Hardstone vases and bowls in silver gilt or gilt-bronze had been favoured luxury objects since the Renaissance. In the context of documenting design, this drawing is interesting in that its purpose is absolutely clear. It is marked as a design by Dugourc, as royal designer, for Ange-Joseph Aubert (1736–1785). Dugourc, in the tradition of Le Pautre and Berain, worked as a designer of objects for the French and later the Spanish royal courts. After studying in Italy and working in Paris as designer for the Duc d'Orléans and the Paris Opéra, in 1784 he was appointed *Dessinateur du Garde-Meuble de la Couronne*. In this capacity, he designed interiors, furnishings, and objects of all types for various French royal households until the Revolution.

Aubert had been a master goldsmith in Paris since 1762 and *Joailler du Roi* since 1773.[1] In 1774, he collaborated with another goldsmith, Auguste, to make the crown for the coronation of Louis XVI. He was a wealthy man by the time of his death in 1785, and the sale of his possessions, which began on 2 February 1786, included 243 lots. As Fuhring points out, lots 203 and 204 are objects described as very similar to the bowl in this design. One is even made of red jasper, as specified in this design. The bowls in the Aubert catalogue are recorded as being 5 *pouces* and 6 *lignes* tall, or about 14 cm, just slightly larger than the actual size of the bowl in the drawing. Additionally, Fuhring cites a green jasper cup in the Louvre,[2] that is quite similar to this design.

44. Jean-Démosthène Dugourc,
French (1749–1825)

Design for Mounts for a Jasper or Agate Bowl, 1784

Pen and black ink with brown wash on laid paper
200 × 271
Inscribed above centre: *Jaspe sanguin/Agate*; below left: *Pour Monsieur Aubert/J.D. Dugourc del. 1784*
Literature: Fuhring 1989:382–385, no. 597

Museum Purchase: Gift of
Mrs. Mona Campbell
991.64.3

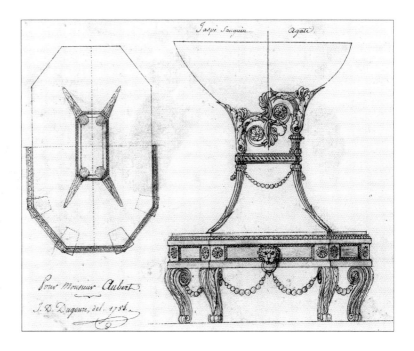

NOTES
1. For Aubert, see Watson 1956:124.
2. Louvre, Paris, inv. OA15.

45. Gottfried Bernhard Göz, German
(1708–1774)

*Design for a Facade Painting with
Allegorical Figures of Earth and Air,*
1740–1743

Pen and brown ink with grey wash with
white heightening over black chalk on laid
paper
352 × 205
Literature: Fuhring 1989:243–244, no. 276

Museum Purchase: Gift of
Mrs. Mona Campbell
991.64.8

This drawing had been identified by Fuhring as a design for an illusionistic portal. It is probable, however, that the scheme is for the illusionistic painting of a house facade, surrounding a real window. The construction of the scheme makes no sense for a doorway. Were the lower edge of the rectangular opening the ground line, the caryatids would have to be three-dimensional. Although Göz may have designed a sculptural surround for a portal, it is known that he was engaged in painting house facades during the period of the early 1740s. Further evidence against its use for a portal is that the figures are two of the Four Elements. This makes no sense except as a pair with a second identical portal, which is unlikely in even the grandest patrician house in Augsburg. It could, however, easily be one of two such decorated windows in a facade.

Born in Moravia, Göz arrived in Augsburg in 1729 or 1730, and in 1733 received the right to practise his profession there as an independent master. He worked as a designer, engraver, and publisher of prints, as well as a painter throughout the next decade. In 1744, Emperor Charles VII named him an Imperial Court Painter and Engraver, testifying to his good reputation as an artist.

The first fresco by Göz of which we have any trace is an *Allegory of the Good Fortune of Commerce and Trade,* still extant in Augsburg, and signed and dated 1739.[1] The painting was commissioned by a banker for a stairway. The drawing for the fresco shows a similar treatment of architecture, and the shell forms, taken from French art, are clearly related to the rocaille forms in the ROM drawing. Isphording speculates that this fresco is so complicated that it cannot have been Göz's first work. He may well have gained experience in such architectural decoration by painting facades.

Since the Renaissance, the stuccoed facades of South German, Austrian, and Swiss buildings have been decorated with paintings. Unlike the largely traditional style of current paintings of this kind (which is, significantly, a popularization of Rococo style), facade painting was once the domain of high-style work by important artists. The major works of Johann Holzer, one of the great Augsburg painters of the 18th century, were facade paintings. However, due to their constant exposure to weather, outdoor frescos are a transitory medium. None of the 18th-century Augsburg painted facades survived into the 20th century.

Göz is known to have painted at least three facades. One, for the house of the goldsmith Franz Thaddäus Lang, was still visible in 1886 to Adolf Buff, who dated it to 1740.[2] Buff also attributed another facade, dated 1758 or 1759, to Göz. Based on Buff's description, neither can be related to the ROM drawing. In 1752, Göz designed and was paid for executing allegorical frescos on the famed Perlach Tower of Augsburg's City Hall.[3]

The ROM drawing is from a more developed stage of Göz's

96 Gottfried Bernhard Göz

ornamental style than the 1739 drawing of *The Allegory of Commerce and Trade*, and shows more exaggerated Rococo forms, for example, in the highly irregular shell shapes that end the volutes above the lower window, or the large shell at the top. It is quite similar to several other drawings from the very early 1740s.[4] The style of draftsmanship and some of the minutiae of the ornament are also quite comparable to that in a drawing of St. Florian, in Stuttgart, dated 1741[5] and to a drawing in Munich for a ceiling painting with mythological figures dated 1743.[6] Conversely, the ROM drawing is an earlier stage of Göz's work than the design for a ceiling fresco of *The Senses and Temperaments* in the Städtische Kunstsammlungen in Augsburg.[7] That drawing, dated 1751, shows disintegrating rocaille forms and much less density of ornament. Fuhring draws attention to a smaller version of the drawing in the Museum für Angewandte Kunst in Vienna, squared for transfer, implying that the design was carried out.

NOTES
1. Isphording 1982–1984:213, no. A I 1.
2. Buff 1886–1887, XXII:174–175.
3. See Isphording 1982–1984:219, no. A I 9, for the drawing and relevant information.
4. Fuhring 1989 makes a comparison to several other drawings: Isphording 1982–1984, no. A III b 128 (Kunstbibliothek Berlin, inv. 2973); Isphording, no A III b 124 (Kunstbibliothek Berlin, inv. 6256); Isphording, no. A III a 59 (Kunstbibliothek Berlin, inv. 4580); Isphording, no. A III b 134 (Staatsgalerie Stuttgart, inv. 3922); and Isphording, no. A III a 80 (Staatsgalerie Stuttgart, inv. 623), which is less relevant.
5. Isphording 1982–1984:248–249, no. A III a 55a; also Stuttgart 1990, no. 11, colour ill. The drawing is a preparatory drawing for an engraving.
6. Isphording 1982–1984:214, no. A I 3.
7. Isphording 1982–1984:217–218, no. A I 7.

46. Johann Esaias Nilson, German
(1721–1788)

Design for an Allegory of "The Eternal,"
1757

Black chalk, pen and black ink with grey
wash, heightened with white on laid paper
Inscribed below right: *Inv. et dessiné p:
J.E.Nilson 1757*
186 × 261

Museum Purchase: Gift of
Mrs. Mona Campbell
992.38.1

Nilson was the finest ornament draftsman in Augsburg during the 18th century. As pointed out in the discussion of No. 19, he was quite conscious of the issues of representation that could be addressed in ornament, and his work shows an unusual and original treatment of Neoclassical forms. This variation seems not to be a misunderstanding of the issues involved in the transition from Rococo to Neoclassicism, but a deliberate manipulation of Neoclassical ideas. Nilson was never able to make a complete evolution to a Neoclassical style of his own; in fact, he seems to have resented the change in fashion.

This previously unpublished drawing, clearly dated 1757, is an allegorical composition dominated by a female figure with an open Bible, an extinguished candle, and an hourglass. Her foot rests on a globe and before her breast is a flaming winged heart with an eye. At the top, angels fly down to her with a martyr's palm, another branch, a crown, and a laurel wreath, all symbols of devotion to God. Juxtaposed with her in the right corner are symbols of worldly vanity: an ornamental shepherd's staff, a flag, a bale of merchandise, a crown, a representation of a "Jewish" priest's mitre, a globe, a viol, and, finally, as the chief symbols of vanity, a skull and *homo bulla,* a putto blowing bubbles. Perhaps meant to be included in the *Vanitas* grouping, or perhaps just part of the setting, is an elaborate Baroque urn. In the distance beyond a formal garden is a Baroque building, possibly a palace or a convent. The entire composition is set into the ambiguous space typical of Nilson's work. To the right, a thin Rococo border functions as a picture frame, with the scene apparently placed behind it in a stage-like space. The spatial position of the descending angels is unclear, while the still life to the right is in front of the parallel hatching of the picture plane. In front of all of this is the delicate Rococo cartouche at the lower centre.

The drawing can only have been intended as the design for a print. It was used in slightly altered form for an etching entitled *The Eternal,* which is the pendant to a composition titled *The Temporal.*[1] The latter shows a man and woman in contemporary clothing standing before Roman ruins. The woman carries a walking stick, and the man, apparently a scholar or learned tourist, points out a detail of a classical inscription. *The Temporal* includes no abstract Rococo framework. A palm tree used as a framing device is the type of Rococo element Nilson could never completely eliminate from his Neoclassical works. Nilson represents the temporal, not with generic worldly splendour, but with Roman antiquity and with an Enlightenment amateur regarding ruins, as was the current fashion. He deliberately equates an interest in classical antiquity with the vanity of human endeavour, and represents Rococo as the style of Christian religiosity. This can only be a deliberate response to the

challenge of Neoclassicism, which had arrogated to itself the position of the morally correct art of the Enlightenment.

The interpretation of the two prints is complicated by their history. Although the drawing is dated 1757, the etching of *The Eternal* is signed "J.H. f." by Josef Huber. Born in 1759, he trained with Nilson before leaving for Paris in 1778.[2] The pendant, *The Temporal,* for which the drawing is not known, was engraved by Nilson's daughter, Rosina Catherina Nilson, who lived from 1755 to 1785.[3] The ages of the artists would indicate that the prints can hardly be from before the mid 1770s, and the publication number of the pair within Nilson's publications, no. LVI, also indicates a date of the mid 1770s.

Were the drawings done as a pair in 1757, intended to represent these two concepts, or was the ROM drawing created simply as an allegory of Faith in combination with some other image to make a print set which was never completed? *The Temporal* includes a palm tree with a column base and a sarcophagus at the right, which are reversed copies of elements from Piranesi's *Vestigi d'Antichi Edifici,* plate 5 of the *Prima Parte,* first published in 1747.[4] It might be argued that the Piranesi would have been more current in 1757 than

Rosina Catherina Nilson (1755–1785)
after Johann Esaias Nilson
The Temporal
Etching
Staatliche Graphische Sammlung, Munich

1775, when there would also have been many more sources for antique motifs.

In 1757, there was much controversy in Augsburg's artistic circles.[5] One of the Augsburg art academies, with imperial patronage, had a markedly Neoclassical bias. In that year, it elected a new president, and took on renewed vigour in its propaganda for an art of "rationality" and its attacks on Rococo style. As a Protestant, a supporter of the other Augsburg academy, and a Rococo artist, Nilson may well have prepared a pair of drawings as a counterattack. Why the designs were not engraved is unknown.

During the 1770s, Nilson dealt with the coming of Neoclassicism in several works, most notably in an engraving of an artist standing next to a Neoclassical monument and tearing up a sheet of paper which reads "Muschelwerk" (rocaille). He then began to try to adapt to the style, although with little success. One can imagine that the extant drawings may have come to mind, or he may have reinterpreted the earlier allegorical image of *The Eternal* by designing a Neoclassical counterpart to be issued as a pair of etchings.

NOTES
1. Schuster 1936:92, nos. 208, 209.
2. Schuster 1936:271.
3. Schuster 1936:251–252.
4. Robison 1986:102, no. 16.
5. Bushart 1968:281–282.

47. Unknown Artist, German
(Augsburg)

Design for a Silver Table Centrepiece,
1755–1760

Grey wash on laid paper
524 × 577

Museum Purchase: Gift of
Mrs. Mona Campbell
990.132.1

The large number of drawings similar to this full-scale design for an elaborate table centrepiece documents the popularity of these objects, which now exist in only a small number of examples. Such centrepieces were the focal point of large silver services, an important product of the silver industry in 18th-century Augsburg.[1]

These silver centrepieces evolved in the later 1740s from a type that was developed in France in the mid 17th century, reaching its full development by the early 18th century. A few examples survive, such as the centrepiece by Claude Ballin in the Hermitage in St. Petersburg, datable to 1726.[2] The form consisted of a platform on which could be placed small dishes for confections and sauces, decanters for oil and vinegars, or casters for sugar and spices. In the centre of the platform is either a large bowl for fruit or an ornamental structure often surmounted by figures and usually incorporating candleholders. The French versions remain primarily architectural in their structure and decoration, and incorporate figures as caryatids or as decorations on top of the central pavilion.

The Augsburg formula for the design of these pieces becomes much more elaborate. Augsburg centrepieces usually retain the base platform, which holds the containers for condiments, but it now becomes the locale for a figural composition. A sculptural scene is set beneath the silver superstructure that ordinarily, as in this example, supports a basket for lemons and occasionally has arms with candleholders. The platform itself can be left plain or sculpted as a naturalistic form such as a forest floor or a formal garden. Similarly, the c- and s-curved supports of the superstructure are not always made of abstract rocaille forms, but can imitate architecture, trellis work, or even trees. The centrepiece becomes an elaborate tableau, coincidentally holding tablewares. They are exemplary of the Rococo tendency to completely merge abstraction and representation, structure and decoration, ornament and function. Centrepieces of this type were produced in Augsburg from the late 1740s until about 1760.

The design shown here incorporates two male figures in the central scene, representing what must be Wisdom and Ignorance. At the right, the wise man is shown with an open book, a candle, a globe, a compass, and a try square, as he observes and contemplates the world. To the left, a blindfolded man has knocked over a wine glass. He has playing cards on the ground at his feet, and gropes unseeing and unknowing through space. The two figures may refer to the senses as a source of wisdom. This might relate to the theme of the putti in the superstructure above. The three sets of putti represent, from left to right, Sight, Hearing, and Smell. These are three of the Five Senses (Touch and Taste are absent), although there would appear to be only one place (on the unseen side of the basket) for an additional pair.

The drawings, like the actual centrepieces, are quite informative about the genesis of Rococo design. Only two or three of all the drawings for these centrepieces show a perspective view of the object with all four supporting legs of the superstructure, although the surviving examples all have four legs. For clarity, the rear supports are omitted. This causes the drawing itself to resemble much more closely the Augsburg Rococo ornament prints. These prints usually show figures in association with a huge rocaille form with relatively little depth. The prints, which are really independent images rather than patterns for specific objects, are close in conception to the centrepieces. The drawings normally provide a rather unusual combination of perspective views, with the figures and superstructure seen head-on, and the platform shown from a slightly elevated angle, to show its shape with maximum clarity. This causes the figural scene of the centrepiece to appear to float on an island in space, like the figures in Rococo ornament prints. Since the two media developed simultaneously, it remains to be determined if the syntax of printed ornament had a direct effect on the three-dimensional conception of the centrepieces.

Perhaps a dozen Augsburg Rococo centrepieces survive but there are well over a hundred drawings for them. Their existence indicates that the centrepieces were much more common than we might otherwise realize. The drawings are all similar in size to the ROM example, thus essentially at one-to-one scale with the object. Several survive with indications that they were contract drawings, shown to the patron for formal approval. The cause for the survival of so many drawings is unclear. They are concentrated in two collections, the Städtische Kunstsammlungen Augsburg and the Staats- und Stadtbibliothek Augsburg, and they may well all have originated with the same silver dealer.[3] The surviving Augsburg silver designs show remarkably consistent style in draftsmanship. In fact, the drawings for centrepieces seem to have been made by only four or five draftsmen, probably not silversmiths. The only signed drawing is by Franz Joseph Degle, a painter of miniatures.[4] Without further study, it is unclear if they are proposed designs for objects, if they illustrate objects already extant, or if they demonstrate what could be compiled from elements present in the silver dealer's stock.[5]

NOTES
1. For a description of one service and an overview of the subject, see Augsburg 1985.
2. The development of these pieces is described in Bursche 1974:36–42. The Ballin piece is ill. 248.
3. See Bursche 1974:40–41; 33, nn. 170–173. There is a volume of Augsburg silver designs of the 1750s in the Musée des Arts Décoratifs, Paris, many of which are reproduced throughout Gruber 1982.
4. Staats- und Stadtbibliothek Augsburg, inv. 60/28.
5. For the role of the dealer in the Augsburg silver industry, see Augsburg 1985:8–13, and Rathke-Köhl 1961. The three centrepieces in the Hildesheim set are similar but not identical to a number of drawings in the Augsburg collections, leading to the conclusion that moulds for various parts were available and could be combined in differing constellations to form completed pieces.

48. Unknown Artist, German

Design for a Silver Bookcover, 1761

Pen and brown ink with grey wash over
pencil on laid paper
357 × 235
Inscribed centre: *Anno MDCCLXI*
Literature: Fuhring 1989:401, no. 645

Museum Purchase: Gift of
Mrs. Mona Campbell
991.64.1

NOTES
1. A large selection of silver bindings was
illustrated in a sale catalogue, Sotheby's,
Silver and Enamel Bindings, London, 10 May
1985. The books are primarily individual
devotional books rather than Bibles or
missals.
2. Identified by Fuhring 1989:401, no. 645.
3. Lindner 1903:200–205.
4. Lindner 1903:78.
5. Stutzer 1978:304–309.

This drawing is an alternative design for a silver plaque to be
applied to the cover of a book. Like the Augsburg drawing for a sil-
ver centrepiece, this design provides a glimpse of an entire genre
that has virtually disappeared.[1] It is thus an important document of
South German monastic church silver. In the bold, full-blown
Rococo of the last phase of the style in South Germany, the cover
has a central boss with a bust-length image of Christ. The bosses in
the corners show the Four Latin Fathers of the Church. Clockwise
from upper right are Jerome, Augustine, Ambrose, and Gregory.
These portraits might be engraved in silver or, on a truly magnifi-
cent book, coloured enamel on plaques inserted into the cover. Only
a Bible or a missal for use at the altar would have such a luxury
binding. Since a Bible would be more likely to show the Four
Evangelists, this would probably be for a missal. It has not proven
possible to identify a maker through stylistic or archival evidence.

Above the central portrait of Christ is a panel with the date 1761.
Below him is the coat of arms of Gregory von Plaichshirn, Abbot of
the Benedictine Monastery of Tegernsee from 1737 to 1762.[2]
Gregory was particularly active in enriching the monastery with his
donations and acquisitions. He especially promoted the acquisition
and even printing of liturgical books. In the chronicle of the
monastery, the posthumous description of his accomplishments
praises him for his contribution to adorning the church with such
pieces as baldachinos, reliquaries, and altar crosses.[3] It is easy to
imagine a splendid missal among this grouping. Unfortunately, no
books are described.

Fuhring speculated that the book may not have been carried out,
but there are no grounds for that assumption. In the years before
the complete secularization of church property in Bavaria in 1803,
the Tegernsee monastery was forced to surrender much of its silver
to the Electoral Mint in Munich. A list of the objects relinquished
was prepared by the abbot in 1801.[4] There are thirty-two entries,
some with more than one object. Entry 23 is "The silver mounts of 8
Missals." Item 30, the silver mounts for one missal, was purchased
back by the abbot because of its artistic or religious significance.
Clearly, a large number of such bindings were destroyed. So much
silver came to the mint from the secularized church property that it
added significantly to inflation.[5]

While such wholehearted use of Rococo style would have been
far out of fashion in France in 1761, it still had currency in South
Germany, especially for religious uses. The connection of Rococo
with religious sentiment, which continues today in South Germany,
is also seen in the work of Johann Esaias Nilson (No. 46).

These two drawings are taken from an album of gouache designs for floral embroideries, primarily patterns for the borders of scarves (called *fichus*), dresses, decorative aprons, and men's vests and jackets. From their format, these two are apparently designs for embroidery on the divided front of a woman's dress *à la polonaise*. The album, bound in heavy vellum covered in a 17th-century Genoese silk brocade, contained twenty-five drawings. Seventeen sheets were actually bound into the album and another eight were simply placed inside. Those bound into the cover are fairly large, ranging from 30 to 40 cm wide and 100 to 140 cm long. Although some of the drawings were badly wrinkled and all had been folded, most were in unusually good condition for embroidery designs.

Three of the drawings in the portfolio are in black only. Rather than showing a pattern for black embroidery, these may be for white-on-white stitching, which would have been a challenge to show otherwise. Textile designers in the 18th century had developed many similar techniques for representing monochromatic texture rather than colour in cloth.

The designs in the album show a range of the stylized floral patterns in use for embroideries across Europe at the end of the 18th century. However, French embroidery patterns of the period are usually of finer quality than these drawings, with more delicate forms and more harmonious colour combinations. Fortunately, the watermarks in the album are quite informative. There are three different marks, all from Berne and all dated between 1792 and 1800.[1] The coincidence of three Berne manufacturers in one collection is strong evidence for localization. However, two of the drawings simply inserted into the album have English and Dutch watermarks of the 1790s.[2] They may not have originated in the same shop as the bound drawings but, since they are contemporary with the other drawings and in similar style, they were probably placed in the book during the period. The added drawings include four patterns for the embroidery of men's vests.

The drawings are probably a salesman's sample book, demonstrating patterns available from his workshop. The binding, which may originally have held many more designs, allowed for ease in travel and display. Patterns were transferred to cloth by pouncing,[3] and only two of the drawings, which are among those that were loose in the binding, are pricked for transfer. These fairly straightforward designs were meant to be worked in silk thread, in a simple satin stitch.

Charles-Germain de Saint-Aubin, in his 1770 treatise on embroidery, made an observation about design which holds true for more than just embroidery:

> It is necessary for the designer to add to his talent a knowledge of the details and difficulties of embroidery, in order to conform to the possibilities

a

b

of execution. Similarly, it is to be desired that the workers would have at least the beginning elements of Design, in order not to corrupt the forms and fittings, which happens too frequently. I repeat, Design is the soul of embroidery and it is the design that gives offense in the works of the majority of nations about which I will speak.[4]

No. 49b, detail

NOTES
1. See Lindt 1964, from the makers S. E. Gruner (Lindt, nos. 651, 652), Jean Baptiste Guerdat (Lindt, no. 777), and Kirchberger (Lindt, no. 628).
2. Design ROM 990.65.1.17 has watermark of J. Whatman 1794. Design 990.65.1.22 has watermark of J. Honig & Zoonen.
3. Saint-Aubin 1770:5.
4. Saint-Aubin 1770:4.

In the 18th century, shawls woven with complex patterns of "pine-cone" motifs were imported into Europe from India and became quite fashionable. In 1805, the textile manufacturers in Paisley joined other textile centres in making European imitations of these products. Very shortly thereafter, Paisley's dominance of the British market was so complete that the shawls became known as "Paisley shawls," and the characteristic pine-cone motif was dubbed a "Paisley." By 1870, fashion had changed and shawl production virtually ceased, although some of the factories lived on until the 1940s.

In 1987, the ROM received a gift of forty-one designs for Paisley shawls from a family that had emigrated from Scotland in the previous generation. Through reliable family history, they knew that the

50. Unknown Artist, Scottish

Four Designs for Paisley Textiles, 1860s

Pencil and watercolour (a, d) and pencil (b, c) on wove paper

Gift of James, Elizabeth, and Doreen Browning

a. 357 × 209
987.235.37

b. 385 × 215
987.235.40

c. 378 × 203
987.235.41

d. 378 × 229
987.235.35

a

designs had been obtained from one of the Paisley textile firms before its closure, although which firm was not known. Based on the style of the pattern, the drawings are datable to the 1850s and 1860s, the late period of production of Paisley pattern shawls in Paisley, after the shawls had begun to be printed instead of woven with the pattern. The drawings demonstrate several aspects of the design of Paisley patterns, from pencil sketches to finished gouache drawings on oiled paper.

These four drawings are apparently initial sketches for printed shawls. They are scaled down somewhat from the dimensions of the finished shawl. The design of each drawing would be repeated in each corner of the shawl to form four symmetrical repeats,

b

c

leaving only a very small blank area in the centre of the shawl. This type of "full-field" Paisley design became popular in the 1860s. The drawings are also datable to the period around 1870 by their resemblance to other textile design of the period. Some Paisley patterns had included very realistic and three-dimensional forms in the 1850s. However, the overlapping of forms and resultant shallow space, seen in Nos. 50b and 50c, and the use of stylized natural forms of leaves and plant tendrils, seem to hint at the developments in textile design of the more avant-garde work of the Arts and Crafts Movement, which began in the 1870s. The curving leaves and tendrils bear more than a passing resemblance to the work of William Morris and others in the movement.[1]

NOTE
1. See Parry 1988. Oddly, Paisley shawls are not mentioned in the book.

d

Included in the gift of designs for Paisley shawls (No. 50) were two impressions on paper of "blocks" for printing Paisley textiles. The two impressions are from the same printing surface, inked in slightly varying colours. Although the design could be earlier, the impressions can probably be dated to the 1860s. Printing textile for shawls had begun in Paisley by at least about 1850, but printing textile from rollers was not introduced until about 1860.[1] This design was most likely printed from rollers, since the repeat is only a few inches in either direction.

51. Unknown Artist, Scottish

Impression on Paper of Woodblocks for Textile Printing, 1860s

Woodcut
298 × 273 (sheet)

Gift of James, Elizabeth, and Doreen Browning
987.235.32

NOTE
1. Reilly 1989:19–20.

52. Workshop of Peter Carl Fabergé,
Russian (1846–1920)

Box Cover with a Piece of Moss Agate,
c. 1900

Pencil and watercolour on wove paper
255 × 171

Museum Purchase: Gift of
Mrs. Mona Campbell
989.139.1

In 1870, Peter Carl Fabergé took over his father's successful gold-smithing business in St. Petersburg. During the next forty-eight years, he made the name of his company into a synonym for luxury and quality throughout the world. Fabergé, despite his training as a goldsmith, is not known to have made any objects. That the "style" of Fabergé products had any consistency at all is a testament to his skill as an artistic director and to the managers and workmasters of his workshops.[1]

Fabergé had taken a study trip through western European collections as a young man, and had been especially impressed with the decorative arts of 18th-century France. The seemingly infinite resources poured into materials and craftsmanship during the 18th century was perhaps matched only in the products of Fabergé's firm. As a crowning glory to the string of revival styles marking 19th-century decorative arts, the Louis XVI revival of the period from 1890 to 1914 was brought about in part by the choice of that style for much of Fabergé's production. Hapsburg credits the success with this style largely to the work of Henrik Wigström, who was head workmaster in St. Petersburg from 1903 until 1918.[2] The delicate and precise linear style of the historical precedents merged well with the cold perfection of Fabergé's production.

The sensitive and lavish use of semi-precious stone is a hallmark of Fabergé's production. Picture frames were made with swags of coloured gold, such as are shown in this design, but the central oval of moss agate does not seem to be simple filler. Rather, the design is for an elaborate box lid incorporating the beautiful stone as decoration.[3]

NOTES
1. For Fabergé in general, see Hapsburg-Lothringen and Solodkoff 1979, and Munich 1986.
2. Munich 1986:68.
3. Simpler box covers with moss agate are illustrated in Hapsburg-Lothringen and Solodkoff 1979:82, ills. 97, 99.

These two drawings are steps in the design of a single object. In No. 53a, the designer is developing an idea for a *kovsh*, or traditional Russian cup. The designer experiments with the shape of the handle, as well as its relation to the scale of the cup. Several shapes for the cup itself are tried. Two related versions of the raised decoration for the outside of the cup are seen in the drawing above and those below. Number 53b is a "fair copy" of parts of the first drawing. Tracing paper has been used to copy the elements selected. The top view with the handle is traced from the first sheet. The decoration in the side view is also traced from the lower version in the first sheet, but the cup itself is larger than the main drawing of the first sketch.

Traditional Russian forms for vessels and Russian subject matter in figural works were popular products for Fabergé's firm. This traditionalism was given a great impetus with the Pan-Russian exhibition of 1882, and continued to gain popularity leading up to the celebrations of the three-hundredth anniversary of the Romanov dynasty in 1913.

53. Workshop of Peter Carl Fabergé,
Russian (1846–1920)

Designs for a Kovsh, c. 1900

Museum Purchase: Gift of
Mrs. Mona Campbell

a. Pencil and watercolour on wove paper
185 × 157

Rim of cup: [fragmentary Russian inscription]
989.140.1.1

b. Pencil and watercolour on tracing paper
115 × 138

989.140.1.2

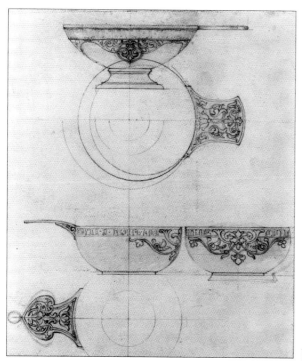

a

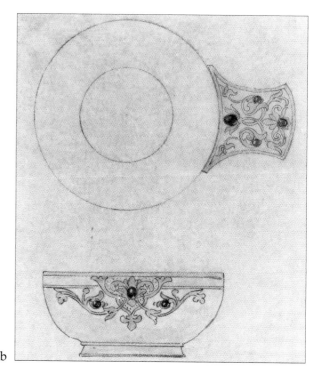

b

54. Josef Hoffmann, Austrian
(1870–1956)

Design for Ceramic Tablewares, c. 1915?

Pencil on squared wove paper
297 × 420
Inscription: *an drei Stellen/Salz Zucker/*
[illegible]/aussen braun innen weiss.
[JH monogram in two places]

Museum Purchase: Gift of the American
Friends of the Royal Ontario Museum
990.54.2

Hoffmann was one of the creators of modern decorative style with his work for the Wiener Werkstätte from 1903 until 1931. His early work was revolutionary in its simple rectangular forms with restrained geometric decoration. As the years went on, his designs for objects became more lively, more curvaceous, and more dependent upon colourful decoration.

This design for ceramic tablewares shows a modern way of meeting the concern for harmony within a set of related objects. The three sizes of cups are lined up one atop the other so that their coherence as a set can be judged. The dotted interior lines show a section of the actual ceramic. Although no decoration is shown, the note at the right side says simply, "brown outside, white inside."

Hoffmann's designs can often be difficult to date, for he constantly returned to earlier ideas for inspiration.[1] The severe monochromatic decoration of this set would be typical of his early work, as is the very solid, squat form of the pieces.[2] On the other hand, the obvious join of the handles to the bodies, with a slight curve away from the body at the lower join, is much like that of a mocha service of the early 1930s.[3] The variations over time in Hoffman's use of his monogram are also rather confusing.

NOTES
1. Vienna 1987a:18.
2. Compare to a porcelain service of about 1910, in Vienna 1987b, nos. K1–K6.
3. Vienna 1987b, nos. K8, K9.

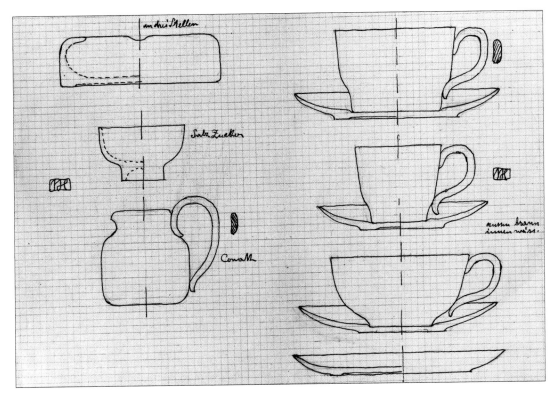

55. Paul Kiss, French, born Budapest
(1886–1962)

*View and Plan for a Wrought Iron and
Copper Plant Stand*, 1925–1930

Blueprint
352 × 260
Inscribed above left: [stamp of Paul Kiss
workshop]; above right: *No. 3266*

Gift of Hermann Levy
991.212.2.2

Paul Kiss was a Hungarian who settled in Paris in 1907 and then worked for the metalwork designers and forgers Edgar Brandt and Raymond Subes.[1] He established his own shop after World War I, was active exhibiting with Société des Artistes Décorateurs, and provided items for the historic 1925 Exposition International des Arts Décoratifs. Working in a style very similar to that of early Brandt, he included geometric motifs with stylized birds and plants in his work. The scrolls that create the openwork basket of this plant stand are a typical feature of his work.[2]

The ROM owns the plant stand shown (ROM 983.230.46), acquired from the same donor as the blueprint. The blueprint seems to be intended more for the potential purchaser than as a working drawing since it does not provide very detailed information about the construction of the piece. It may have been from the shop's book of samples or intended for the customer to carry away. The latter seems likely, as the donor had blueprint drawings of both Paul Kiss pieces in his collection. The blueprint was perhaps used as an efficient means of producing a limited number of copies of a drawing.

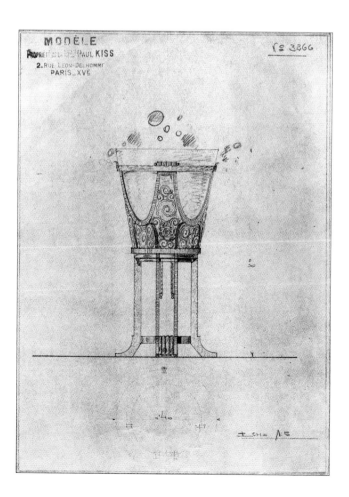

NOTES
1. Rutherford and Beddoe 1986:64.
2. Morgan 1990:69.

WORKS CITED

Aldersey-Williams 1992
Aldersey-Williams, Hugh. *World Design: Nationalism and Globalism in Design.* New York, 1992.

Amsterdam 1979
Blaauwen, A. L. den., ed. *Nederlands Zilver 1580–1830.* Exhib. cat., Rijksmuseum Amsterdam, 1979.

Arents 1949
Arents, Prosper. "Pompa Introitus Ferdinandi. Bijdrage tot de Rubensbibliografie." *De Gulden Passer* XXVII (1949), pp. 81–348.

Augsburg 1985
Müller, Hannelore. *Das Hildesheimer Tafelservice. Meisterwerke der Augsburger Goldschmiedekunst.* Exhib. cat., Städtische Kunstsammlungen Augsburg, 1985.

Bartsch 1803–1821
Bartsch, Adam von. *Le peintre-graveur.* 21 vols. Vienna, 1803–1821. (2nd. ed., Leipzig, 1818–1876.)

Bauer 1962
Bauer, Hermann. *Rocaille zur Herkunft und zum Wesen eines Ornament-motivs.* Berlin, 1962.

Baulez 1982
Baulez, Christian. "Ange-Jacques Gabriel. Les résidences royales. Versailles." In *Les Gabriel,* M. Gallet and Y. Bottineau, eds., pp. 144–167. Paris, 1982.

Berlin 1939
Katalog der Ornamentstichsammlung der Staatlichen Kunstbibliothek Berlin., 2 vols. Berlin, 1936–1939. Staatliche Museen zu Berlin. (Reprint, Utrecht, 1986.)

Berlin 1981
Stamm, Birgitte. "Vorbilder für Fabrikanten und Handwerker. Zur preussischen Gewerbeförderung in der 1. Hälfte des 19. Jahrhunderts." In *Karl Friedrich Schinkel. Architektur, Malerei, Kunstgewerbe,* cat. nos. 312–329, pp. 333–336. Exhib. cat., Verwaltung der Staatlichen Schlösser und Gärten, Berlin, 1981.

Berliner and Egger 1981
Berliner, Rudolf, and Egger, Gerhart. *Ornamentale Vorlageblätter des 15. bis 19. Jahrhunderts.* 3 vols. Munich, 1981.

Brandimarte 1991
Brandimarte, C. A. "Japanese Novelty Stores." *Winterthur Portfolio* XXVI, 1 (Spring 1991), pp. 1–25.

Buff 1886–1887
Buff, Adolf. "Augsburger Fassadenmalerei." *Zeitschrift für bildende Kunst* XXI (1886), pp. 104–109; XXII (1887), pp. 173–178, 275–277.

Bursche 1974
Bursche, Stefan. *Tafelzier des Barock.* Munich, 1974.

Bushart 1968
Bushart, Bruno. "Augsburg und die Wende der Kunst um 1750." In *Amici Amico. Festschrift für Werner Gross,* M. Gosebruch and K. Badt, eds., pp. 261–304. Munich, 1968.

Chippendale 1754
Chippendale, Thomas. *The Gentleman and Cabinet-Maker's Director.* 1754. (Reprint of 3rd ed. of 1762, New York, 1966.)

Cleveland 1975
Eidelberg, Martin, and Johnston, William R. "Japonisme and French Decorative Arts." In *Japonisme: Japanese Influence on French Art 1854–1910,* pp. 141–155. Exhib. cat., Cleveland Museum of Art, 1975.

Croft-Murray 1962–1970
Croft-Murray, Edward. *Decorative Painting in England 1537–1837.* 2 vols. London, 1962–1970.

Dacier and Vuaflart 1921–1929
Dacier, Emile, and Vuaflart, Albert. *Jean de Jullienne et les graveurs de Watteau au XVIIIe siècle.* 4 vols. Paris, 1921–1929.

Dacos 1969
Dacos, Nicole. *La découverte de la Domus Aurea et la formation des grotesques à la Renaissance.* Studies of the Warburg Institute 31. London and Leiden, 1969.

Downes 1959
Downes, Kerry. *Hawksmoor.* London, 1959.

Eidelberg 1984
Eidelberg, Martin. "Huquier—Friend or Foe of Watteau?" *Print Collector's Newsletter* XV, 5 (Nov.–Dec. 1984), pp. 157–164.

Fields 1985
Fields, Armond. *George Auriol.* Layton, Utah, 1985.

Focillon 1918
Focillon, Henri. *Giovanni Battista Piranesi, essai de catalogue raisonné de son oeuvre.* Paris, 1918.

Frankfurt 1983
Hanebutt-Benz, Eva-Maria. *Ornament und Entwurf.* Exhib. cat., Museum für Kunsthandwerk, Frankfurt am Main, 1983.

Frankfurt 1992
Die Grosse Utopie. Die Russische Avantgarde 1915–1932. Exhib. cat., Schirn Kunsthalle, Frankfurt am Main, 1992.

Frederiks 1952–1961
Frederiks, Johan Willem. *Dutch Silver.* 4 vols. The Hague, 1952–1961.

Frégnac 1966
Frégnac, Claude, et al. *French Master Goldsmiths and Silversmiths from the Seventeenth to the Nineteenth Century.* New York, 1966.

Frühe Plakat 1977
Malhotra, Ruth, et al. *Das frühe Plakat in Europa und den USA. Ein Bestandskatalog. II. Frankreich und Belgien.* Berlin, 1977.

Fuhring 1989
Fuhring, Peter. *Design into Art: Drawings for Architecture and Ornament: The Lodewijk Houthakker Collection.* London, 1989.

George 1952
George, Waldemar. *Louis Süe.* Paris, 1952.

Geymüller 1887
Geymüller, Henri de. *Les Du Cerceau: leur vie et leur oeuvre.* Paris and London, 1887.

Gilbert 1978
Gilbert, Christopher. *The Life and Work of Thomas Chippendale.* 2 vols. London, 1978.

Ginestet and Pouillon 1979
Ginestet, Collette, and Pouillon, Catherine. *Jacques Villon. Les estampes et les illustrations.* Paris, 1979.

Gonzalez-Palacios 1981
Gonzalez-Palacios, Alvar. "Diversi maniere d'adonare i cammini." *In* Piranesi, Giambattista, *Piranesi: incisioni, rami, legature, architetture,* pp. 56–61. Vicenza, 1981.

Gruber 1982
Gruber, Alain. *Silverware.* New York, 1982.

Grushkin 1987
Grushkin, Paul. *The Art of Rock: Posters from Presley to Punk.* New York, 1987.

Guilmard 1880–1881
Guilmard, Désiré. *Les maitres ornemanistes.* 2 vols. Paris, 1880–1881.

Hague 1952
Frederiks, Johan Willem. *Vier Eeuwen Nederlands Zilver.* Exhib. cat., Gemeentemuseum, The Hague, 1952.

Hapsburg-Lothringen and Solodkoff 1979
Hapsburg-Lothringen, Geza von, and Solodkoff, A. von. *Fabergé: Court Jeweler to the Tsars.* New York, 1979.

Harries 1983
Harries, Karsten. *The Bavarian Rococo Church: Between Faith and Aestheticism.* New Haven, 1983.

Hayward 1952
Hayward, John Forest. "Four Prints from Engraved Silver Standing Dishes Attributed to J. T. de Bry." *The Burlington Magazine* XCV, 601 (April 1952), pp. 124–128.

Hempel 1989
Hempel, Frithjof. "Schinkels Möbelwerk und seine Voraussetzungen." Ph.D. diss., Universität Bonn, 1989.

Hernmarck 1977
Hernmarck, Carl. *The Art of the European Silversmith 1430–1830.* 2 vols. London and New York, 1977.

Hollstein 1949–1969
Hollstein, F. W. H. *Dutch and Flemish Etchings, Engravings, and Woodcuts, ca. 1450–1700.* Amsterdam, 1949–1969.

Hollstein 1954–
Hollstein, F. W. H. *German Engravings, Etchings and Woodcuts, ca. 1400–1700.* Amsterdam, 1954–.

Illustrated Bartsch 1978–
Strauss, Walter L., ed. *The Illustrated Bartsch.* New York, 1978–.

Inventaire XVIe siècle
Bibliothèque Nationale, Département des estampes. *Inventaire du fonds français: graveurs du XVIe siècle.* Paris, 1932–.

Inventaire XVIIe siècle
Bibliothèque Nationale, Département des estampes. *Inventaire du fonds français: graveurs du XVIIe siècle.* Paris, 1939–.

Inventaire XVIIIe siècle
Bibliothèque Nationale, Département des estampes. *Inventaire du fonds français: graveurs du XVIIIe siècle.* 12 vols. Paris, 1930–1973.

Isphording 1982–1984
Isphording, Eduard. *Gottfried Bernhard Göz 1708–1774. Ölgemälde und Zeichnungen.* 2 vols. Weissenhorn, 1982–1984.

Jamnitzer 1610
Jamnitzer, Christoph. *Neuw Grottessken Buch. Nachdruck der Ausgabe Nürnberg 1610.* (Intro. by H. G. Franz. Graz, 1966.)

Juchheim 1976
Juchheim, Goda. "Das 'neuw Grottessken Buch' Nürnberg 1610 von Christoph Jamnitzer." Ph.D. diss., Munich, 1976.

Katz and Indiana 1971
Katz, W., and Indiana, Robert. *Robert Indiana. Druckgraphik und Plakate. 1961–1971. The Prints and Posters.* Stuttgart and New York, 1971.

Lees-Milne 1970
Lees-Milne, James. *English Country Houses: Baroque 1685–1715.* London, 1970.

Lemonnier 1983
Lemonnier, Patricia. *Weisweiler.* Paris, 1983.

Levron 1941
Levron, Jacques. *René Boyvin, graveur angevin du XVIe siècle.* Angers, 1941.

Lindner 1903
Lindner, P. *Historia Monasterii Tegernseensis (1737–1803). (Beiträge zur Geschichte, Topographie und Statistik des Erzbistums München und Freising N.F. II).* Munich, 1903.

Lindt 1964
Lindt, Johann. *The Paper-Mills of Berne and Their Watermarks., 1465–1859.* Monumenta Chartae Papyraceae Historiam Illustrantia X. Hilversum, 1964.

Mamiya 1992
Mamiya, Christin J. *Pop Art and Consumer Culture: American Super Market*. Austin, 1992.

Marie 1984
Marie, Alfred, and Marie, Jeanne. *Versailles au temps du Louis XV, 1715–1745*. Paris, 1984.

Martin 1972
Martin, John Rupert. *The Decorations for the Pompa Introitus Ferdinandi*. Corpus Rubenianum Ludwig Burchard, XVI. London and New York, 1972.

Mayhew 1967
Mayhew, Edgar de N. *Sketches by Thornhill in the Victoria and Albert Museum*. London, 1967.

Morgan 1990
Morgan, Sarah. *Art Deco: The European Style*. London, 1990.

Munich 1986
Hapsburg, Geza von. *Fabergé: Hofjuwelier der Zaren*. Exhib. cat., Hypo-Kulturstiftung, Munich, 1986.

Münster 1985
Luckhardt, Jochen, et al. *Heinrich Aldegrever und die Bildnisse der Wiedertäufer*. Exhib. cat., Westfälisches Landesmuseum für Kunst and Kulturgeschichte, Münster, 1985.

New York 1981
Byrne, Janet S. *Renaissance Ornament Prints and Drawings*. Exhib. cat., Metropolitan Museum of Art, New York, 1981.

New York 1987
Fuhring, Peter. "A Newly Discovered Album of Goldsmith's Designs." In *An Exhibition of Ornamental Drawings 1550–1900*, unpaginated. Exhib. cat., Armin B. Allen, Inc., New York, 1987.

New York 1988
Wye, Deborah. *Committed to Print: Social and Political Themes in Recent American Printed Art*. Exhib. cat., Museum of Modern Art, New York, 1988.

New York 1992
Myers, Mary L. *French Architectural and Ornament Drawings of the Eighteenth Century*. Exhib. cat., Metropolitan Museum of Art, New York, 1992.

Nyberg 1969
Nyberg, Dorothea. *Meissonnier: An Eighteenth-Century Maverick*. New York, 1969.

Paris 1987
Jean-Richard, Pierrette. *Ornemanistes du XVe au XVIIe siècle: gravures et dessins: XIVe exposition de la Collection Edmond de Rothschild*. Exhib. cat., Louvre, Paris, 1987.

Parry 1988
Parry, Linda. *Textiles of the Arts and Crafts Movement*. London, 1988.

Piel 1962
Piel, Friedrich. *Die Ornament-Grotteske in der Italienischen Renaissance. Zu ihrer kategorialen Struktur und Entstehung*. Berlin, 1962.

Plinval de Guillebon 1972
Plinval de Guillebon, Régine de. *Porcelain of Paris 1770–1850*. New York, 1972.

Pradère 1989
Pradère, Alexandre. *French Furniture Makers: The Art of the Ébéniste from Louis XIV to the Revolution*. London, 1989.

Pully 1991
Aitken, Geneviève. *Artistes et théâtres d'avant-garde: programmes de théâtre illustrés. Paris, 1890–1900*. Exhib. cat., Musée de Pully, 1991.

Rathke-Köhl 1961
Rathke-Köhl, Sylvia. *Geschichte des Augsburger Goldschmiedegewerbes vom Ende des 17. bis zum Ende des 18. Jahrhunderts*. Augsburg, 1961.

Reilly 1989
Reilly, Valerie. *Paisley Patterns: A Design Source Book*. London, 1989.

Rietsema van Eck 1982
Rietsema van Eck, P. C. "Bastian Boers en Mathieu Petit, schrijfmeesters, schoonschrijvers en glasgraveurs." *Bulletin van het Rijksmuseum* XXX, 2 (1982), pp. 51–62.

Ripa 1970
Des berühmten Italiänischen Ritters Caesaris Ripae Allerley Künsten und Wissenschafften dienliche Sinnbilder und Gedancken. Reprinted with an introduction by I. Wirth. Munich, 1970.

Robison 1986
Robison, Andrew. *Piranesi: Early Architectural Fantasies*. Washington, Chicago, and London, 1986.

Rutherford and Beddoe 1986
Rutherford, Jessica, and Beddoe, Stella. *Art Nouveau, Art Deco, the Twenties, the Thirties and Post-War Design: The Ceramic, Glass and Metalwork Collections at Brighton Museum*. Brighton, 1986.

Saint-Aubin 1770
Saint-Aubin, Charles-Germain de. *L'art du brodeur*. Paris, 1770.

Salverte 1930
Salverte, François, Comte de. *Le meuble français d'après les ornemanistes de 1660 à 1789*. Paris, 1930.

San Francisco 1976
Medeiros, Walter. *San Francisco Rock Poster Art*. Exhib. cat., San Francisco Museum of Modern Art, 1976.

Schleswig 1991
Spielmann, Heinz, ed. *Die russische Avantgarde und die Bühne, 1890–1930*. Exhib. cat., Schleswig-Holsteinisches Landesmuseum, Schleswig, 1991.

Schuster 1936
Schuster, Marianne. *Johann Esaias Nilson. Ein Kupferstecher des süddeutschen Rokoko 1721–1788*. Munich, 1936.

Snodin 1983
Snodin, Michael. "George Bickham Junior: Master of the Rococo." *V & A Album* II (1983), pp. 354–360.

Snowman 1966
Snowman, A. Kenneth. *Eighteenth Century Gold Boxes of Europe*. London, 1966. (2nd. ed. Woodbridge, Suffolk, 1990.)

Strasbourg 1971
André Mare et la compagnie des arts français (Süe et Mare). Exhib. cat., L'ancienne Douane, Strasbourg, 1971.

Stuttgart 1990
Erwerbungen der Graphischen Sammlung, Staatsgalerie Stuttgart 1983–1990. Exhib. cat., Staatsgalerie Stuttgart, 1990.

Stutzer 1978
Stutzer, Dietmar. *Die Säkularisation 1803. Der Sturm auf Bayerns Kirchen und Klöster*. Rosenheim, 1978.

Tadgell 1978
Tadgell, Christopher. *Ange-Jacques Gabriel*. London, 1978.

Thieme-Becker 1907–1950
Thieme, Ulrich, and Becker, Felix. *Allgemeines Lexikon der bildenden Künstler von der Antike bis zur Gegenwart*. 37 vols. Leipzig, 1907–1950.

Thornton 1978
Thornton, Peter. *Seventeenth-Century Interior Decoration in England, France and Holland*. New Haven and London, 1978.

Troy 1991
Troy, Nancy J. *Modernism and the Decorative Arts in France: Art Nouveau to Le Corbusier*. Yale Publications in the History of Art. New Haven and London, 1991.

Unna 1986
Heppe, Karl Bernd., et al. *Heinrich Aldegrever, die Kleinmeister und das Kunsthandwerk der Renaissance*. Exhib. cat., Evangelische Stadtkirche Unna, 1986.

Véra 1912
Véra, André. "Le nouveau style." *L'Art Décoratif* I (1912), p. 32.

Verlet 1955
Verlet, Pierre. *Le mobilier royal français: meubles de la couronne conservis en France*. Vol. I. Paris, 1955. (2nd. ed., Paris, 1990.)

Vertue 1758
Vertue, George. "A Description of Easton Neston in Northhamptonshire." *In* Fairfax, Brian, *A Catalogue of the Curious Collection of Pictures of George Villiers, Duke of Buckingham*, George Vertue, ed., pp. 53–66. London, 1758.

Vienna 1987a
Josef Hoffmann. Variationen. Bestandskatalog. Exhib. cat., Museum Moderner Kunst, Vienna, 1987.

Vienna 1987b
Noever, Peter, and Oberhuber, Oswald, eds. *Josef Hoffmann 1870–1956. Ornament zwischen Hoffnung und Verbrechen*. Exhib. cat., Österreichisches Museum für Angewandte Kunst, Vienna, 1987.

Vienna 1991
Zu Gast in der Kunstkammer. Exhib. cat., Kunsthistorisches Museum, Vienna, 1991.

Wall 1987
Wall, Frauke van der. "François Spierre. Ein lothringischer Maler und Stecher des 17. Jahrhunderts." Ph.D. diss., Würzburg, 1987.

Ward-Jackson 1958
Ward-Jackson, Peter. *English Furniture Designs of the Eighteenth Century*. London, 1958.

Warhol 1975
Warhol, Andy. *The Philosophy of Andy Warhol: From A to B and Back Again*. New York, 1975.

Warncke 1978
Warncke, Carsten-Peter. "Christoph Jamnitzers 'Neuw Grottessken Buch'—ein Unikat in Wolfenbüttel." *Wolfenbüttler Beiträge* III (1978), pp. 65–87.

Warncke 1979
Warncke, Carsten-Peter. *Die ornamentale Groteske in Deutschland 1500–1650*. 2 vols. Berlin, 1979.

Watson 1956
Watson, F. J. B. *Wallace Collection Catalogues: Furniture*. London, 1956.

Weigert 1937
Weigert, Roger-Armand. *Jean I Berain: dessinateur de la chambre et du cabinet du roi, 1640–1711*, 2 vols. Paris, 1937.

Weinhardt 1990
Weinhardt, Carl, Jr. *Robert Indiana*. New York, 1990.

Wilton-Ely 1978
Wilton-Ely, John. *The Mind and Art of Giovanni Battista Piranesi*. London, 1978.

Worsdale 1983
Worsdale, Marc. "Le Bernin et la France." *Revue de l'Art* LXI (1983), pp. 61–72.